BOLLINGEN SERIES XXXV · 8

THE A. W. MELLON LECTURES IN THE FINE ARTS

Delivered at the National Gallery of Art, Washington, D. C.

Frontispiece: GABO: Linear Construction No. 4, Black. *1955, aluminum and stainless steel*, H. *38½ in.*

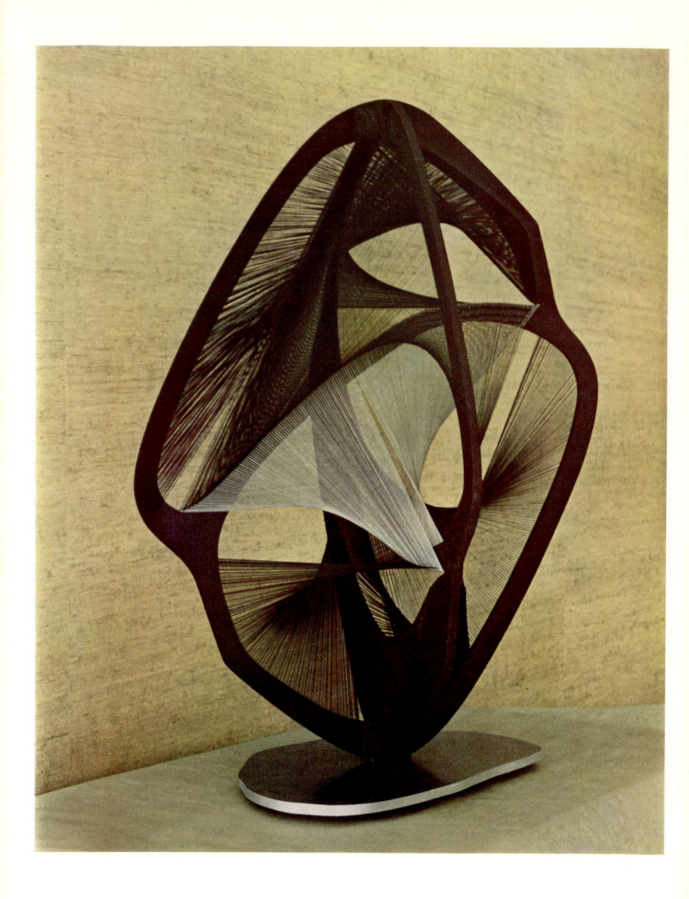

The A. W. Mellon Lectures in the Fine Arts

National Gallery of Art, Washington · 1959

OF DIVERS ARTS

NAUM GABO

BOLLINGEN SERIES XXXV · 8

PRINCETON UNIVERSITY PRESS

COPYRIGHT © 1962 BY THE TRUSTEES OF THE
NATIONAL GALLERY OF ART, WASHINGTON, D.C.
PUBLISHED BY PRINCETON UNIVERSITY PRESS,
PRINCETON, N.J.

This is the eighth volume of the A. W. Mellon Lectures in the Fine Arts, which are delivered annually at the National Gallery of Art, Washington. The volumes of lectures constitute number XXXV in Bollingen Series.

Library of Congress Catalogue Card No. 62–9369
Manufactured in the U.S.A.

First Princeton/Bollingen Paperback printing, 1971
ISBN 0-691-01771-9

To My Brothers MARK and ALEXEI

TABLE OF CONTENTS

ACKNOWLEDGMENTS

I AM GRATEFUL to the National Gallery of Art, Washington, D.C., without whose initiative this book would never have been written. I thank my friends Robert Richman and Herbert Read for their encouragement; my brother Alexei Pevsner, and the various officials of the State publishing house of the U.S.S.R., "Iskusstvo," the State Tretyakov Gallery, the State Historical Museum, the "Soviet Artist" Publishing House, and the International Book House, all in Moscow, for providing many of the photographs of Russian art reproduced here; Dr. Robert Goldwater, for advice on primitive art; Mr. H. V. Baker, Mr. Frank Waslick, and the staff of Publicity Engravers, Inc., for their devotion to the task of achieving color engravings of remarkable quality; and Mr. William McGuire of Bollingen Series for his help and co-operation. I want also to thank my wife, Miriam, for her patience and encouragement during the time this book has been in preparation.

N. G.

LIST OF ILLUSTRATIONS

An asterisk marks an illustration given in color.

OF DIVERS ARTS

I

MR. CHAIRMAN, LADIES AND GENTLEMEN: When I was first asked to deliver this series of lectures, I was given to understand that I was invited for the sole reason that I am an artist, and that I might speak about anything I wished without being bound to one particular theme. It was explained to me that the National Gallery of Art would like to introduce to its public an artist in the flesh, in order that you might be in more personal contact with him than by merely seeing his work, and in the hope that you might get an idea, from the sources where art is generated, of the mental mechanism of the artist.

As you see, I have accepted the honor offered me.

Whether, of the thousands upon thousands of artists in the world, I am the one to speak for them all; whether what I shall say to you will have the merit of being the paragon, the classic model of the mental world of all of them, I of course very much doubt. Indeed, you may already know that my art is not the kind of art which is commonly accepted, approved, and understood; it differs greatly from what the majority of artists are doing, and it differs also from what the public in general expects of a work of art. My art is still the subject of controversial opinions regarding its value, its purpose, and its place in

Of Divers Arts
I

our society [1]. The mere fact that many students of art, and I myself, are trying to classify it by giving it the special names of "abstract" and "constructivist" makes it plain that we want it to be known as a distinct form of art, different from other forms of art.

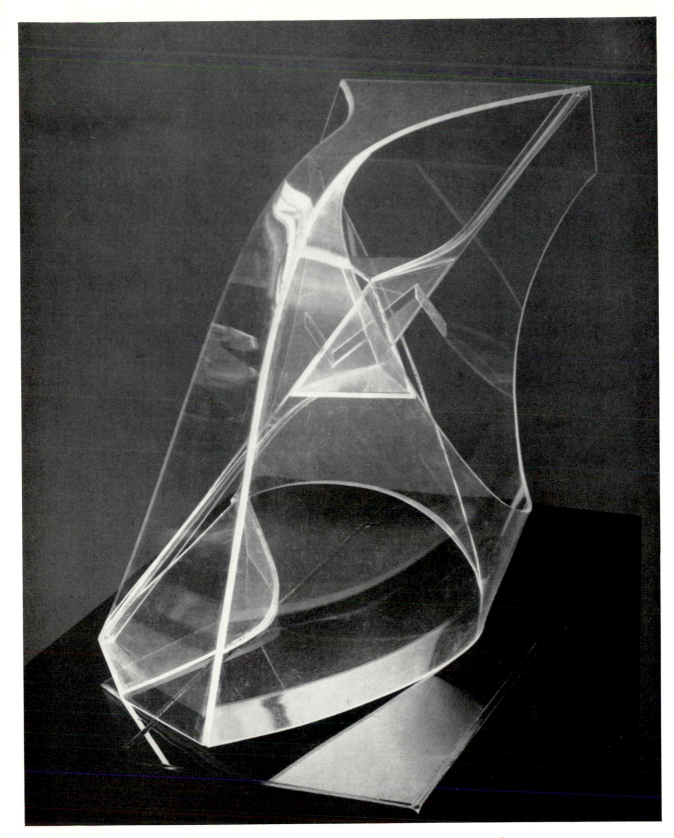

1 GABO: Construction in Space with Crystalline Center. *1938, clear plastic,* w. *18½ in.*

Some have said that I am the end of sculpture, some say that I am the beginning; and although I know that where I am in my art there is no end and no beginning, I cannot deny that the content and the form of my work deviate from that established tradition which the artists of many generations before me have followed, and that my approach to the visual aspects of Nature and of Man in Nature derives from a different point of view, and therefore may legitimately seem to the public, at first glance, strange and open to question. Yet there is one particular aspect of the artist's mentality that is common to all of us. It is this:

The artist's mind is a turbulent sea full of all kinds of impressions, responses, and experiences as well as feelings and emotions. Some experts on Art assert that the artist does not really have more of these emotions and feelings and impressions than the ordinary man who is not an artist. This may be true or false, but what they apparently fail to see and to assert is that in the artist these feelings and responses are in a more agitated state. He is more concerned with them, and the urge to express these experiences is more intense in him than it is in the ordinary man. And that, I suppose, is the reason why the artist's mind is not only turbulent but sometimes, alas, troublesome also. And in that respect, indeed, I am no different from my fellow artists.

However, you will be on much safer ground while

Of Divers Arts
I

6

listening to me, if you are forewarned that I, as an artist, am only one representative of the species of men called artists. And if, while listening to my expositions, you find contradictions in my thoughts, fantasies in my imagery, and if perhaps the whole content of what I am going to say seems to you paradoxical, you had better tell yourselves from the start that "that is just how this particular artist's mind is spinning."

OF ALL that has been written and spoken on art by artists before me, one voice in particular comes to the forefront of my memory from the depths of the long past, almost a millennium ago. In his book, which he wrote around the year 1100, that artist introduces himself to me (for his book was written for all artists whosoever they may be) thus:

"I, Theophilus, humble priest, servant of the servants of God, unworthy of the name and profession of a monk, wish the guerdon of heavenly reward to all who are willing to shun and tread underfoot, by useful handiwork and delectable meditation of novelties, all idleness and wandering of mind. . . ."[1] He tells me that "man was made in God's likeness; the Devil deceived him and deprived him of Paradise, yet not of this inborn capacity to learn divers arts."[2]

And to quote further: "Thou therefore, beloved son, whosoever thou mayest be, into whose heart God hath

set the yearning to explore fully that great and wide field of divers arts, whereby those things are offered freely unto thee which many others acquire by intolerable travail, cleaving the sea-waves with much peril of their lives, constrained by need and cold and hunger, yet oppressed by an overwhelming desire to learn; do thou now greedily behold and covet this *Little Scroll of Divers Arts*, read it through, hold it fast in memory. For, if thou study it with all diligence, thou wilt here find whatsoever Greece hath in mixtures of colours, Tuscany knows of laborious mosaic, Arabia displays in casting metal, Italy adorns with gold, France loves in precious variety of windows, Germany approves in work of gold, silver, copper or iron, timber or stone."[3]

And "whensoever thou makest good use of my labours, thou shalt commend me in prayer to the mercy of Almighty God, who knoweth that I have written the things here set forth neither for love of man's praise nor for covetousness of worldly reward, nor again have I enviously or jealously held back aught that is precious or rare, to reserve such things for myself alone; nay, rather, for the increase of His honour and the glory of His name have I succored many men's needs and taken thought for their profit."[4]

Of Divers Arts
I

From ages past that voice comes to me today like a faint echo from distant mountains. It calls forth in me a certain envy of the deep, devoted faith of that artist in

the purpose of his labor and in the value of all the knowledge he believed an artist must possess if he is to be worthy of God's blessing. That artist knew exactly what he was working for and what he had to do.

And here am I at the other end of a millennium, about to unroll my own little scroll of divers arts, but deprived of the conviction that those virtues which Theophilus sincerely believed to be the main purpose of his labor are of the same value today.

It is by no means my purpose to expound before you a code of rules that the artist must know, for it was and still is abhorrent to me to submit to any rules in my art, and therefore it is just as abhorrent to me to impose them on anyone else. Neither is it my intention to develop new theories or doctrines or techniques about the creation of a work of art. He who wants to know about all those things can find the answers in any textbook.

Nor can I promise to disclose any particular secrets of the trade which my contemporaries, the artists, as well as you, the public, need to know if they are to accept my art, for I know that in a work of art there are not and should not be any secrets; that whatever secrets a work of art may contain, it is the observer who dispels them by experiencing that work of art.

I am incapable, I warn you beforehand, of solving for you any problem in the field of art, or any of the haunting problems of our life today. The only thing I can tell you

9

about those problems is that one should not look for a solution of any problem at its end; for the solution of every problem is hidden in its beginning.

What I am going to try to do, then, is to carry out, to the best of my ability, just what I am expected to do; to bring myself before you and open for you the doors of my workshop. But before you enter that workshop of mine, I shall have to show you certain chambers of my mental self, and guide you along those paths of my thoughts and ideas which I had to traverse before I could become what I am.

To begin with, I would like to disabuse you of the common prejudice you may also share, of believing that an artist is not a thinking creature; that he works only with so-called "inspirations," and that those inspirations are his sole privilege.

Of course the artist has inspirations, but if by inspiration you mean a total acceptance of a single experience— a state of being dissolved entirely in that one experience— if you mean such a state as that, then it is an occurrence common to all human beings.

Of Divers Arts
I

Every experience of which our consciousness is aware, be it trivial or grave, is an inspiration in itself. Our very life, when we come to think of it, when we are conscious of it, is nothing else but a constant stream of those exalted moments of inspiration. Life deprived of this unique characteristic of being able to feel our feelings, of being con-

scious of our consciousness, of experiencing our experiences
—such a life is meaningless, inhuman.

The great majority of people are so used to that state
that they take it for granted; but when they speak of an
artist's inspirations they imagine them as a kind of cloud
in the sky; in fact, they may even take the artist himself
for a kind of cloud in the sky—though in trousers.

I can assure you that it is not so. The artist does think;
he reasons, he works with his intelligence; he needs his
intelligence not only to know what he is going to do in his
art, but even when he is working on it; he reasons just like
you do, although he may not always be reasonable. The
problems of life which bother you, bother him too. Quests
for an answer, for a clear understanding of what is going
on in this world of ours and his, of our existence in it, be
it external or internal to him: all these quests in which
you may be engaged are his quests also. And nothing is
more intolerable to our inmost being than the absence of
an answer to these questions.

I myself have sought for an understanding; I too have
searched for an answer to these questions, and whatever
answer I may have found for myself to clarify in my own
mind what I am doing in my art, I may be able to share
with you in the course of these talks.

EVER SINCE my very early days, when consciousness
started to grow in me, three states have dominated all my

mental existence. The most forcible, the most compelling of them all, was the state of fear: fear of man—The Man, The Stranger. I cannot recall being afraid of anything but of him. I had no fear of the world outside me; the image of this world was tiny, restricted to the objects and people around me, near me; they were my dear guardians and friends.

I was not afraid of animals; I was one of them in our common domesticated nakedness on the homely pasture of my nursery floor. But bodily fear was always lurking in me, ever ready to strike back at me for the appearance of the Man, the Stranger, whose countenance was not at all clear to me. His image was blurred.

Perhaps it was that man, that giant of fairy tale, whose breath was swifter than the wind, whose voice was louder than the thunder, and the swing of whose arm could lay in ruins cities, forests, and fields: perhaps it was He—the unknown—whom I was told I must fear and obey.

I never knew what he would look like if he were one day to appear before me, but I anticipated with dread the moment of his appearance; and one day I met that man.

Of Divers Arts
I

In one of my exuberant, playful disobediences I wandered away to the nearby woods, where I was forbidden to go alone. I found myself in a green depth of silence, swimming in a hot aroma ever further, enchanted by the still whisper of the multitude of leaves, captivated in a new world of all-absorbing peace and silence.

I was letting myself be dragged by it ever deeper and further into that forest of trees and the bushes between them when, all of a sudden, there he was, standing over me—watching me—the Man, the Stranger—a huge, overwhelming image of a peasant with an ax over his shoulder; and all I remember is the sudden darkness his appearance wrapped about me.

Only later was I told that I had fainted, and that it was the same man, the same peasant, who carried me in his arms safely to my home, a mile away.

Later, as I grew up, as time passed, fear was still present in me, but it was losing its intensity.

I was meeting men, strangers, but I could distinguish them from each other. I gained friends; I learned to love them, and I rather longed to be in the presence of men. I was more afraid of being left alone than of being with them. I went to foreign lands; I met men of all kinds— good men, angry men, wise men, and learned men, and I mixed with the multitudes and crowds of men, of human beings. But amongst all the men I met, I was searching for that wise man whose wisdom would be so irreproach-able and his judgment so unprejudiced that he would open to me the ultimate wisdom and the final truth.

Amongst the learned I was looking for that learned man whose knowledge would be so all-embracing that he would not be so foolish as to believe and insist that his doctrines were the only true ones. Amongst the saintly

men, I was looking for that saint whose conscience would be so impeccable that he would never stain it even at the risk of losing his own faith. I looked for a hero, to follow wherever he should lead, who would not be heading for his defeat by his own victories.

And amongst the millions and millions of human beings enslaved in their everyday submission, I looked for the one who was so resigned to his destiny that he would not explode in violence and vengeance to oppress his oppressor more cruelly than he was himself oppressed.

I looked for such men: I have not found them, but I found the man of the multitude—the human creature like myself; my contemporaries, and amongst them I found myself.

And in their midst, treading with them the dust of this earth of ours, under their feet and mine, I found what I had sought so long in vain. And when in that vast crowded workshop of our daily life, where we all were chiseling out the image of our own existence, I found my own corner, it was there, under the piles of our own chips and shavings, that I found that tiny, dusty, yet sparkling revelation—wisdom it was not; it was so small that the whole of it could be contained in the thimble on my mother's finger.

It revealed to me that he who wants to find the ultimate wisdom has to soar above all heights and cease to be. I found that the man I was so eagerly searching for does not

Of Divers Arts
I

look for ultimate truths—he creates them. Here with me, in this workshop of life, he is creating his own vivifying deceits which he calls truths.

It also revealed to me that the fear I had of the Man—of the Stranger—was rather a fear of his unknown image. And when I found him as my neighbor among the multitude of my contemporaries, I saw that he might be much more afraid of me than I of him, and that it was perhaps up to me to take him into my arms and bring him safely to his home whence he had wandered so frightfully far away.

It revealed to me something more: that the image of man is like the spectrum of a sunbeam, hiding its presence within its rays, yet ever ready to unfold its full radiance the moment we open the prism of ourselves for him to pass through our gates.

No man is one man; in him are many men, and only that one which is in action uncovers to us his identity. But many and various are his reflexes to the manifold impulses of life's demands, and manifold are man's identities.

As you cannot trust the frozen iron not to burn you when you touch it with naked hands, so you cannot trust the flames of man's passions not to turn his heart into a lump of ice in the grip of life's events.

You may see a man in the flesh of the humblest of the humble, the meekest of the meek—a man who would cry like a child on seeing the pains and convulsions of a dying

worm, yet that same man may appear one day in the habit of a cruel warrior, spreading death and devastation, shedding horror and misery upon the meek, the humble, and the innocent—all in the name of the sacred cause of his own delusions.

Dim and deceptive are the reflexes of man's image on his surface, and his bodily features are not identical with the traits of his actuality, if we perceive him and take him as an outsider, a stranger. Only in ourselves, in our own consciousness of his existence and ours, may we find the core that makes him and us human.

That is why, ladies and gentlemen, I have abandoned as futile my efforts to represent him in the vesture of his mortal skin and flesh; that is why I have broken the clay and stones of those graven images I used to make of him in my youth.

ANOTHER, a second state of my mental existence that I vividly recall living through was, and is still, that of awe and enchantment before Nature.

From the very first moment of my becoming aware of Nature's existence—there, outside my four walls, outside that window where Nature was living its own separate life, different from mine, yet wherefrom it was persistently calling on me by the knocking of the branches of its trees on my windowpanes, by the rays of its sun—calling on me to come out and to be with it, in it—from these very mo-

Of Divers Arts
I

ments up till the time when I could stand on my own feet and go out and be in it, I plunged forever into that state of awe and wonder that persists with me until today.

I recall standing there at the center of the all-embracing blue dome above me, knowing that it was there yesterday as it is here today and will be here tomorrow, and will never topple down; I wished that I could take it from the skies and keep it to play with when alone in the secret solitude of my corner.

It was an endless, inexhaustible source of joy for me to be in that wide panorama of miracles, to be able to touch its space and winds and bodies; to breath its fragrance, to see its colors and all the web of images that I knew were hidden in every blade of grass, under every stone, in every splash in a puddle of rain.

The spell which Nature had cast over me in these early days of my conscious existence did not disappear as I grew up. Instead, it grew more intense with my own growth. The more I saw of its splendors, the further it lured me into its new, surprising landscapes; and I tried to fix these landscapes on my paper and canvas, to keep them with me. But the nearer I came to one horizon, the more did new and wider ones open. The deeper I plunged into Nature's marvels, the more awe-inspiring were its miracles. But the image of these miracles I could not catch.

And then I wanted to understand; I wanted to know, to touch the bottom and reach the ceiling of its secrets.

I went in search of those men who I knew ought to know; I asked them to teach me and to tell me what they knew about it; and tell they did, a very great deal.

In the first place, they told me that in order to know I must learn to count. Patiently and laboriously I followed their teaching. I learned the meaning of their signs and symbols; I learned how to use them, I learned their intricacy and the staggering results one can achieve by manipulating them, until I realized that my teachers were so engrossed in their own skill of calculation that they wanted me to believe the image of the world and the secret of Nature is number.

I changed my teachers. I thought it was foolish to think thus. I went to those learned men who confirmed and agreed with my view that it is indeed not so, and that there is more to Nature than just number; that there are certain forces in Nature which act in precise rhythms, behaving according to exact rules, in specific order, whose mechanism we can easily understand and even repeat if we learn the rules.

Of Divers Arts
I

They opened to me the sanctuaries of their laboratories, and there they provided my senses with more powerful and more penetrating faculties. They gave me additional eyes to see the minutiae of Nature's depths, to penetrate into Nature's boundless magnitudes. They gave me new and powerful aids to my hearing, so that I could listen to that music of the spheres of which I had heard before only

from the poets, but could not perceive with my own ears. They put into my hands new powers to dig into the heart of this earth of ours, so that I could touch its beats and feel its pulsations. They made it possible for me to break the unbreakable, and with all those new organs which they added to my own, another new and fascinating, unexpected panorama of images opened before me.

But all the time my teachers kept reminding me that all the images which I was now perceiving were only facets, minute facets of that all-embracing whole which Nature is, and they kept urging me on to investigate still further and not to expect an end to my discoveries. And in order to perform this further investigation with them I had to sharpen my mind also. They told me that I had to learn to reason in the way they reasoned; to think according to the rules of their own thinking; how and what to look for and what to expect to find; and they promised that if I followed in the paths which they had already prepared for me, my finds would be rich indeed.

That their promises were well founded I could already see for myself in the fabulous riches of Nature that they had already discovered, and I followed them in their paths of reasoning; I followed in the steps of their rules of thinking, and in that way staggering experiences began gradually to happen in my consciousness.

In my eager quest for knowledge, for understanding of what Nature is, their path brought me beyond the

limits of Nature's identities and, again, the further I went the more Nature eluded me. That familiar world of mine whose image was to me a conclusive certainty began to expand, and every blade of grass, every drop of rain, every little thing in Nature, alive or dormant, suddenly swelled up and exploded in myriad atoms, while the atoms themselves broke up into a still greater multitude, disappearing in a still greater magnitude of unthinkable dimensions into a space of evasive distances beyond the sun, beyond the stars, beyond the galaxies, into an immeasurable and unimaginable extension, until I found myself utterly lost in a void of nothingness.

My learned teachers in their sincere efforts to satisfy my searching consciousness succeeded in estranging me much further from the world than I had ever been before, and then they abandoned me in that vast, deserted, boundless continuum, with a scrap of paper in my hand and a formula written on it, the meaning of which was, in their own frank admission, "a subject in which they themselves do not know what they are talking about nor whether what they are saying is true."[5]

Of Divers Arts
I

I looked around me for someone to tell me where I was; where it was that I had gone astray and gotten lost; but I found myself alone. My teachers, the scientists, calmly retired into the dusty shelves amongst the books in their libraries, with a last admonition to me that I must never forget that I am just a worm digging my way into

that universal continuum—an admonition which I had already heard from men of another vocation long before I started on my journey with them.

And it was then and there, in that state of utter forlornness, that I realized that the image I had been given by my teachers, the scientists, by their way of looking at Nature, was just another stage setting with all the magnificence and ingenuity that the genius of any artist produces in a work of art.

I realized that in my scientific journey I had been under the power of a magic spell of a work of art whose reality was just as true as the verity of the image in an artist's vision.

It became clear to me that the image of Nature which is created by the scientist in his art and by me in my art by painting the landscapes of Nature as seen from my window is not the whole truth—that we were both looking at Nature as outsiders; we were taking it as something existing far away from us, and in making our images of Nature in this way we were removing it to an infinite distance, thus rendering it inconceivable and unimaginable.

And then there came to my mind another image of Nature which not the scientist but the poet, that anonymous poet who is called folklore, had made for me long ago when he said, "There is nothing in this universe of ours, however far away from us, that is not near to somewhere else." What that poet told me is that as well as

distances in this Nature there are also nearnesses. There is a close unity between me and Nature, and the closest distance of that unity to me is no further than in my own consciousness; in that vivifying experience that I am alive, in that exclusive human capacity of being aware of my own presence in this world.

This awareness brought me back to my own actuality, and to realizing that in truth I was never alone, that my own consciousness was all the time with me, and that far from blaming my learned teachers I ought rather to have a feeling of tenderness and compassion for them, since after all they themselves confess that they do not know.

We were both at fault in seeing Nature, our separateness from it, forgetting all the time that there is nothing in Nature that is not in us, and that whatever we experience in Nature was already present in our awareness of its existence; that Nature is neutral and tolerates anything we attribute to it by our actions, our thoughts, and our manipulations of it. Nature does not demand from us that we either love it or curse it; that we can ascribe to it great beauties or abominable ugliness. There is in Nature chaos and order, and all that we make of it is not itself; it is an image of our own making, a work of art produced by our consciousness, a product of our talent, to make images not *of* Nature but *onto* it.

Once we put Nature outside us and embark on a voyage to catch up with its beginnings and to touch its ceiling,

Of Divers Arts
I

we shall inevitably, sooner or later, come into a void of nothingness; only the presence of our own consciousness in us is our guide out of that nothingness.

It is imperative for us to know beforehand when we embark on a voyage into the infinite that wherever we may travel, whatever planet we may find on our way, our consciousness will be waiting for us there, and we shall never find anything save what that consciousness has prepared for us.

And then it was clear to me that whatever secrets there are in Nature, I can unravel and understand them only through the images which my consciousness forms of my experiences. The images of our life, as well as of Nature, can only be understood when we take them for what they are in our experience, namely, as works of art created by our consciousness.

Now I have come to the point where I shall have to be more specific and explain to you what I mean by a work of art—how far in this respect the artist meets the scientist, and where they part and go their own ways. About that, the next time we meet.

II

LADIES AND GENTLEMEN, it is an established habit with
all students of human knowledge to place Art and Science
in different compartments. They assign the name of Art
exclusively to that domain of creative activity which is
concerned with emotions and feelings. They do so in the
firm belief that the difference between Art and Science
lies much deeper than would appear from a superficial
Of Divers Arts consideration of their methods and means. Science does
II not grant the arts any claim to knowledge; beauty and
pleasure is all it leaves them.

That monopolist claim of Science is by now so wide-
spread and so deeply entrenched that no branch of our

physical and spiritual activity is free from its dictates. The age of Science, of whose coming we were warned long ago, indeed, long before the present century, has now in fact arrived. We are living in the age of Science. It is taken for granted that man's every thought and need must submit to the dictates of Science in order to be approved or accepted.

It is not quite clear to me, however, what we artists are supposed to do. Must we join the ranks of the scientists, keep in step with their regiments? Are we supposed to jump on their bandwagon before it is too late? Or are we perhaps to rush to the front of their legions and trumpet their glories? I for my part am bound to ask the scientist why and on what grounds Art should be relegated to the role of the pedestrian who has to thumb a lift from the passing cavalcades of scientific Cadillacs on the highway of culture.

These questions of mine are not meant to be rhetorical. It is really essential for me to have an answer. I am personally involved in this dispute inasmuch as I have to defend my own art from the accusation which I often hear—that my sculptures are mathematical formulas—and to insist that I can quite well use a rectangle or a circle whenever I need these shapes in my image without paying a heavy toll and tribute to the scientist for them, and that I do so on my own inherited human right of vision. I have to remind the public that my ancestors, the

artists of the cave, saw the sun and moon and represented them as circles long before the scientist had made a compass to draw a circle and calculated its measurements.

Let us examine, then, what is Science and what is Art. We must refer the former question to the scientist, since it is always he who speaks for Science.

But again; who is the scientist: the man who has learned to manipulate mathematical formulas which other men or generations of men before him have evolved? Is he the scientist? Or is it the man who calculates the measurements and draws the blueprints for an airplane, the idea of which another man invented or another generation of men evolved? Is *he* the scientist?

I think the answer will be No. It is the man who had the essential idea and showed the way, who evolved the method of producing that airplane. Those men in whose consciousness the idea of an airplane has been transformed into a concrete physical object which can be used for flight: they are the scientists.

How far back, then, must we go to look for that man or those men? Should we not also include that anonymous man, the poet who created the myth of Daedalus and Icarus? Should we not, perhaps, go still further and seek for those men who told us of angels in the image of man: surely there, in those poetic myths, in those fantasies about the angels, the idea of a winged man was already present; and, incidentally, their image of the flying man was not

Of Divers Arts
II

only an angel, it was also a devil, so they may already have anticipated that possibility too.

The scientist will not concede this. He will say, "The myths, the poetry, and the dreams of men, all these are Art; Science is something else. Science," he will say, "is carrying a new vision of the world as a whole and discovering the true laws of Nature and its true reality." It is Science, he will say, that has at last found the methods and the means of understanding Nature and is able to unravel its secrets and reveal the laws that govern them. It is from the method of thought inherent in the scientific disciplines that our achievements derive, because the ways and methods of Science are securely based on reality and on verified facts.

I think that no scientist could complain that I am saying on his behalf something which he himself would not say. We have ample proofs in our libraries that these words are his, not mine.

So much for the scientist.

As for Art, it is usually not the artist who speaks for it; the scientist claims authority in this field too. But I am here to speak for Art, and what I have to say about Art is this.

The achievements of Science are indeed great and wonderful, but the scientist's assertion that the primary source of these achievements lies in his ways of reasoning and thinking and in his methods of calculation and meas-

urement alone is just not so; Art has a great deal to do with it.

"I ascribe to Art a function of a much higher value and put it on a much broader plane than that somewhat loose and limited one we are used to when we say: painting, sculpture, music, poetry, etc.

"I hold that Art has a supreme vitality, second only to the supremacy of life itself, and that it therefore reigns over all man's creations.

"I denominate by the word Art the specific and exclusive faculty of man's consciousness to conceive and represent the world external to him and within him in form and by means of artfully constructed images—conceptions.

"Moreover, I maintain that this faculty predominates in all the processes of our mental and physical orientation in this world of ours; it being impossible for our consciousness to perceive or arrange or act upon our world and in our life in any other way but through these constructions of an ever-changing yet coherent chain of images—conceptions.

"Furthermore, I maintain that these consciously constructed images are the very essence of the reality of the world which we are searching for.

Of Divers Arts
II

"Consequently, I go on to maintain that all the other constructions of our consciousness, be they scientific, philosophical, or technical, are but arts disguised in the specific forms of their peculiar disciplines."[6]

I quote here my own words because they formulate

concisely the fundamental principles which sustain all human creative endeavor; and they should not be taken as something due to the fastidious mind of an artist.

I am not the only one who holds this idea; I have allies in many camps, among them, of late, even some scientists. True, these are few and far between, and their approach to the meaning of Art is only as close to mine as their own scientific habit of thinking permits them to go and no closer; for, being scientists, they cannot allow themselves to step over the threshold between what they think is reality and what they think is fancy. The artist, in their view, can of course allow himself to jump over that threshold (he is used anyhow, in their view, to running loose in the wide and open fields of thought), but the scientist cannot allow himself such liberties. For him that threshold is a wall.

However, of late, the scientists have been prepared to meet the artists half way. They are willing to concede that perhaps, after all, they too are artists. They would not mind wearing around their heads that romantic aureole which they imagine the artist carries in full view of the public, as an adornment (incidentally, little do they know how painful are the rusty nails in that hoop which the artist is supposed to wear). But when they are told that Science is nothing other than an art, that the images of the world which they construct with their Art are no more and no less real than the reality of that which the artist,

the poet, the composer, the sculptor, the painter is making
—then they rise in indignation; they think this is a degra-
dation of Science.

They persist in their conviction that their scientific
approach to life and to the world is the only real and true
approach to reality.

And it is at this point that I, the artist, have to put
the scientist through a grinding examination on what he
is saying.

Of Divers Arts
II

Before I start my discussion with the scientist, allow
me to lead you by a short sidetrack which is not really very
far off the course of our discussion, but will bring us more
directly to its main point. I introduce to you here a child's
drawing [2].

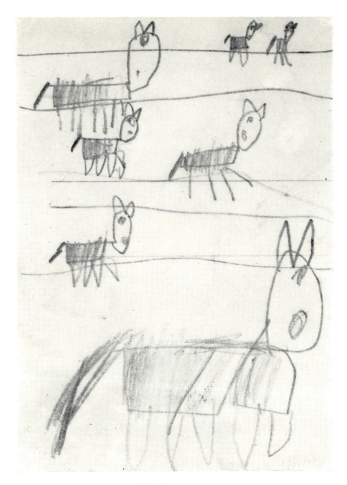

2 Child's drawing of a horse

That child, aged four, is not a fictitious character; I myself witnessed her making that drawing. The grown-ups, amongst whom a scientist was present, asked, "What is it?"

And the child replied, "It is a horse."

"But a horse has only four legs, not five, as you have drawn it," they said. The child, however, unperturbed by that remark, replied, "When a horse is running, he has lots of legs—not only four."

And to prove her point the child produced this [3].

The child had recently been given a ride, and that is her vision from her seat on the horse's back.

Of Divers Arts
II

Now who is wrong and who is right—the grown-up scientist or the child? The sensible, down-to-earth scientist comforts us with the thought that in time, when the child grows up, she will realize that the horse has only four legs and that her representation is wrong.

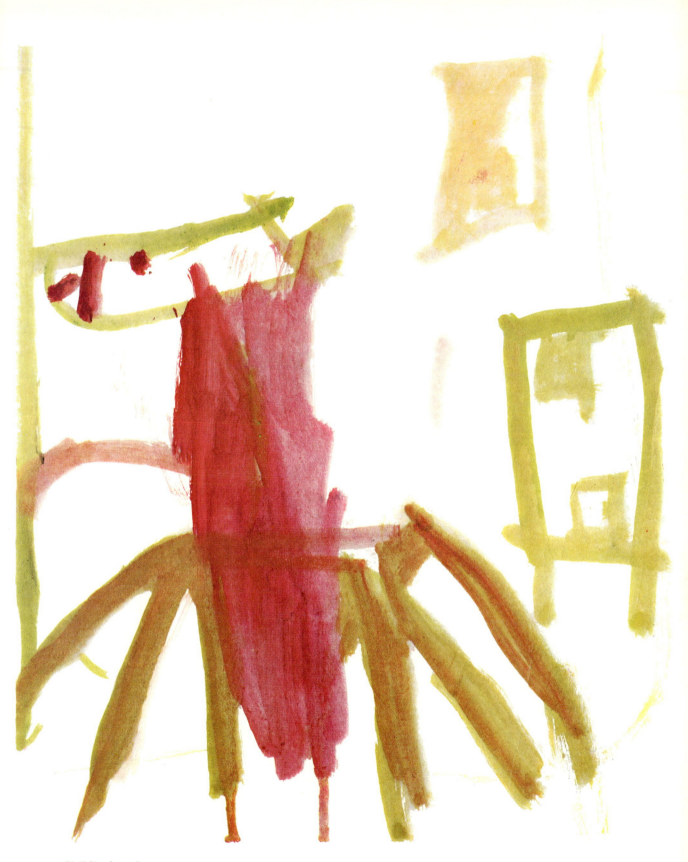

3　Child's drawing

Does the past history of Art confirm such a prediction? Let us take a small section out of that long history and see whether the mental development of the artist during the last hundred years has really followed the path on which the scientist supposes such a child's mentality will develop. Let us transport this child a century into the past, and let us give him a span of life uninterrupted for a hundred years, up to our own day, and assume that this child chose the profession of an artist. At the start, there is no reason whatever to doubt that his first drawing would not differ essentially from this one. He would soon have attended an art school or the workshop of a master, and he would have been taught and trained how to see the world and how to paint it properly, with scientific correctness. And very soon, indeed, he would have learned many more things about this world besides the fact that a horse has only four legs. He would have learned many methods and tricks of how to paint, he would have acquired a knowledge of perspective, he would have learned how to make shadows and contours, and he would have learned many other rules connected with the enlightened progress of Science and knowledge which his time had acquired; he would have

Of Divers Arts
II

progressed from a simple school to an academy, and, knowing all their instructions and doing all they required, he would have been accepted as an accomplished artist and would have been producing paintings, understandable, sensible, and above all, very real—something of this kind [4].

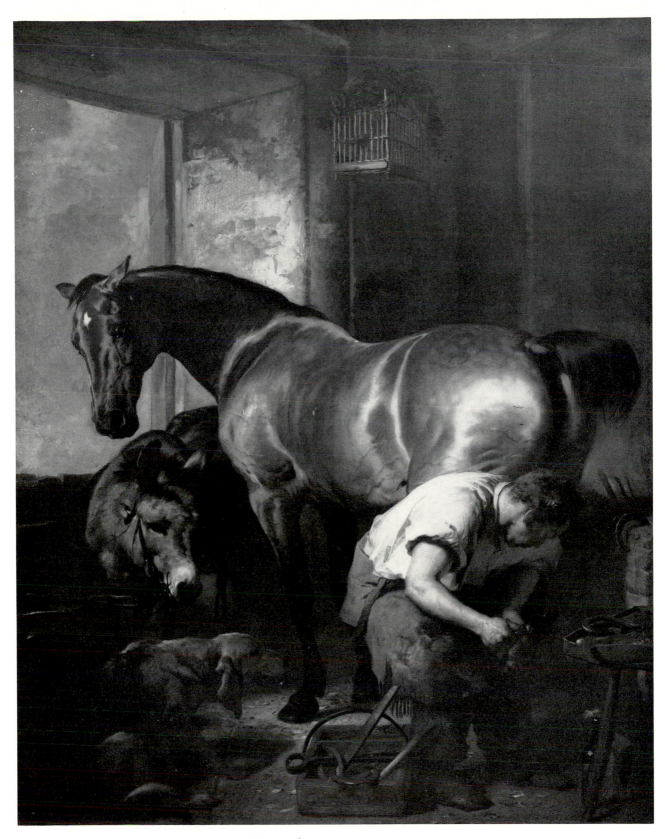

4 EDWIN LANDSEER: Shoeing the Bay Mare. *1844*

But the scientist, who has been after him all the time to see that he does not make any mistakes about the real world, was and is a very cruel creature. One day he suddenly arrives in the artist's studio and produces from his pocket a little one-eyed monster, a gadget. And in a matter of minutes, he makes a picture on whose creation the artist would have had to spend incomparably more time and effort, and in fact, a picture much nearer to the true reality [5].

Of Divers Arts
II

And that is exactly what happened in the world of Art in the second half of the last century.

That sudden performance of the scientist provoked a calamity at that time in our artist's studio, disturbing his mind as well as the minds of his contemporaries. It did

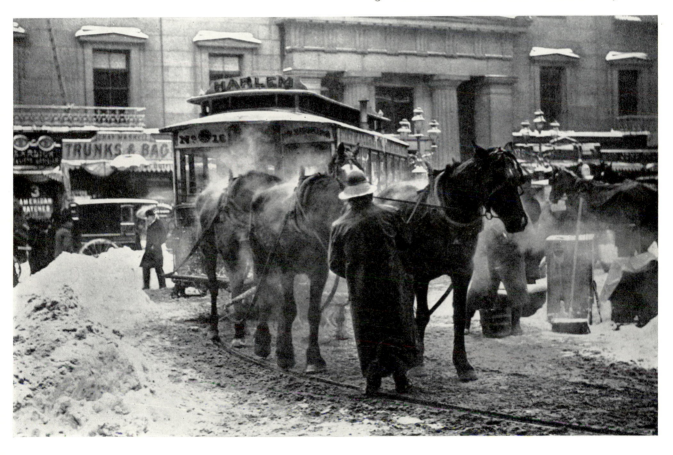

not, however, stop them from painting. On the contrary, they began to wonder whether the image which the gadget produced is really the true image of that which their own vision perceived. And since that image in no way differed from what they were producing in their paintings, there must be something wrong with the pictorial methods they had been taught to use in their way of looking at Nature. And with these doubts, our artist, living in a new generation, goes through a period of intense research in the field of pictorial expression; and, being affected also by the soul-searching which was going on in the scientific mind at that time as well—for its consciousness did not stand still either—he comes to the conclusion that his visual experiences cannot be expressed in the pictorial terms he was taught to use.

He realizes that the academic pictorial terms were correct only in so far as they reproduced an image reflected on his retina but not on his consciousness, and that obviously such a reproduction can be produced mechanically by a gadget which the scientist has invented, and that the inspiration for such an invention is the scientist's inspiration; it responds to the scientist's way of looking at Nature, but not to the artist's.

Of Divers Arts
II

Continuing his artistic career with the new generation, our artist, seeing the performance and following the pictorial experiments contained in such paintings as these [6, 7], turns his attention from the view on his retina

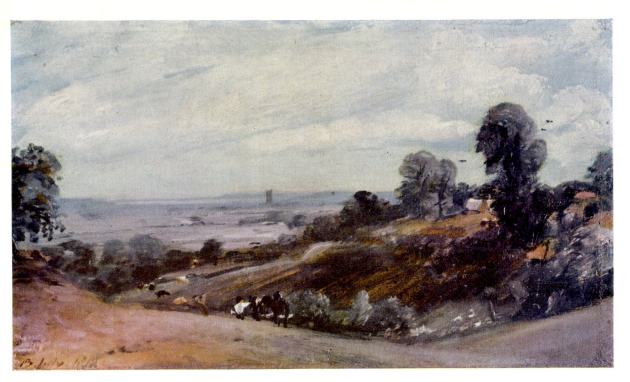

6 JOHN CONSTABLE: Dedham Vale. *1812, oil sketch*

7 JOSEPH M. W. TURNER: An Alpine Valley. *1830–40, watercolor on paper*

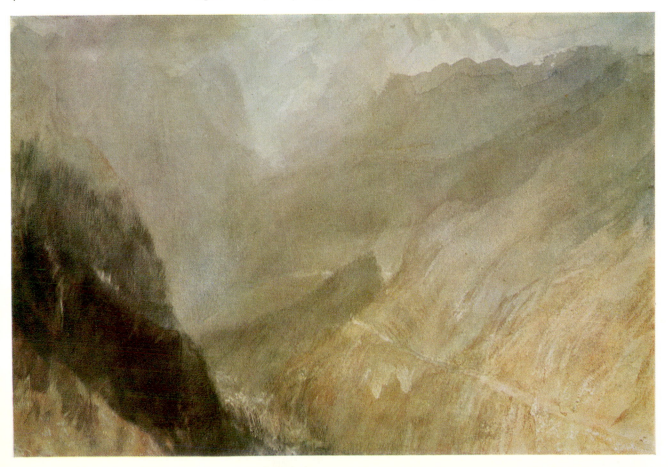

Of Divers Arts

II

alone into the depths of his impression, and he paints paintings like this [8].

He becomes one of those we now know under the name of "Impressionists."

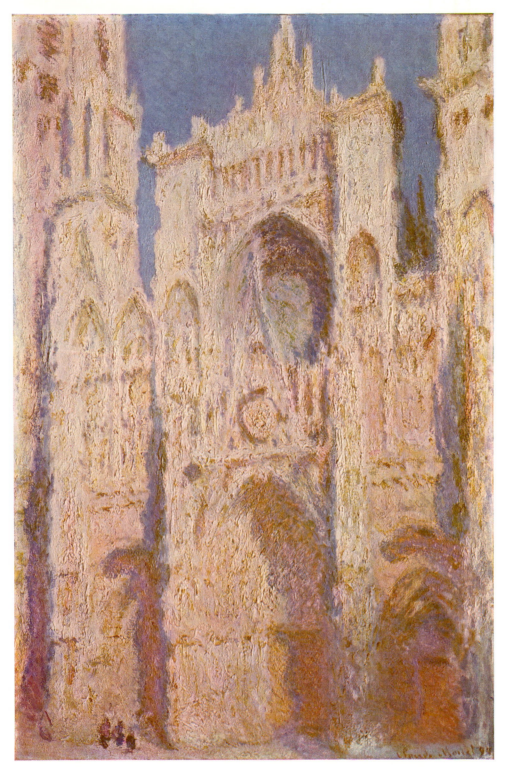

8 CLAUDE MONET: Rouen Cathedral, West Façade, Sunlight. *1894*

It is needless to dwell on the explanation of the theories which underlie the Impressionist movement in art. They are now common knowledge. At any rate, the creative impulse of our artist does not stop here, and no more than the life of one generation had passed when, not even waiting until society understood and accepted the Impressionist way of looking at Nature, another generation arrived at the beginning of our century with a consciousness free from all established ways of thinking and looking at Nature. They went further, investigating the process of their vision and finding new methods of expressing it on a two-dimensional surface. And our artist in that generation produced paintings like this [9].

Such artists called themselves "Futurists."

You may see that our artist, incorporated into this generation, has gone back to his childhood. There are lots and lots of tails on that dog, and lots and lots of legs.

Of Divers Arts
II

42

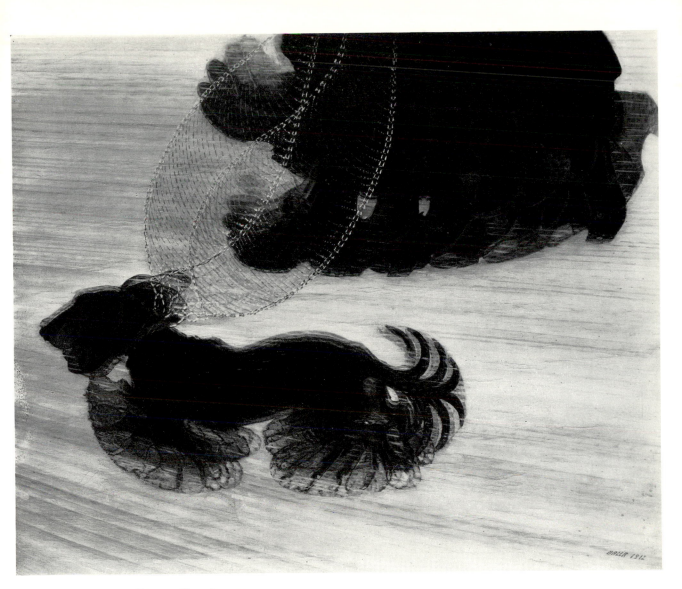

9 GIACOMO BALLA: Dog on Leash. *1912*

Meanwhile, what was our scientist doing? Did his mind remain immobile—his old image of the world stay unaltered? Not at all.

By then the scientist was even further ahead of the artist in his scientific vagaries: deeply engaged in the labor of perfecting a new scientific invention of his—the cinematographic picture—and trying to prove scientifically that our child was originally right and he was wrong.

At that period of the futuristic agitations in Art, Science had already embarked on a new road of revaluation of all the images Science had about Nature and its reality, and had brought about a revolution in the field of Science immensely greater than any other in the history of human intelligence.

In Art, as in Science, once the old norms were broken up, the artistic consciousness was involved, and almost simultaneously with the Futurists another school appeared in the visual arts and went still further in its investigations and experimentations in the field of vision.

Artists began to anatomize the whole image of their surrounding world and of the objects in it to find out what was the pictorial image of the component parts that make up the image and what it is that vision perceives. For that reason they had to break up the whole classical image of the objects they painted, and this is how they did it [10, 11].

That is the stage in which we found the arts—my contemporaries and I, the descendants of the artists of a

Of Divers Arts
II

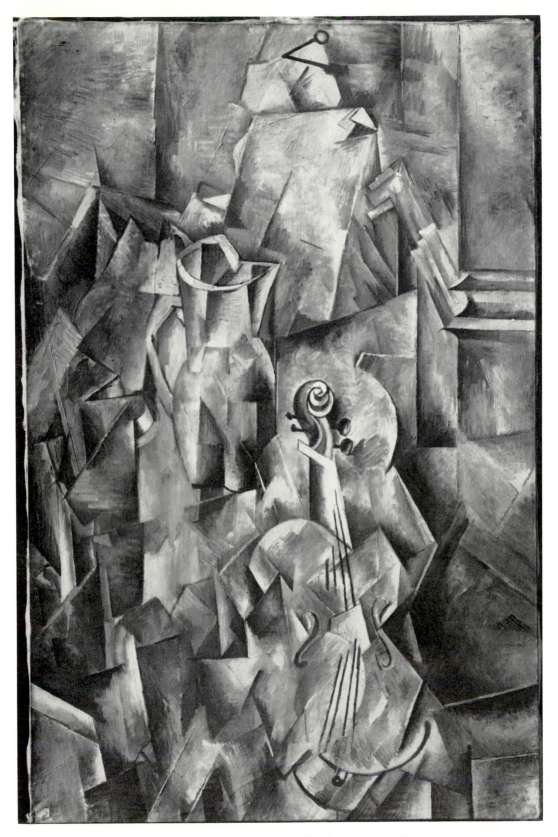

10 GEORGES BRAQUE: Still Life with Violin and Pitcher. *1910, oil on canvas*

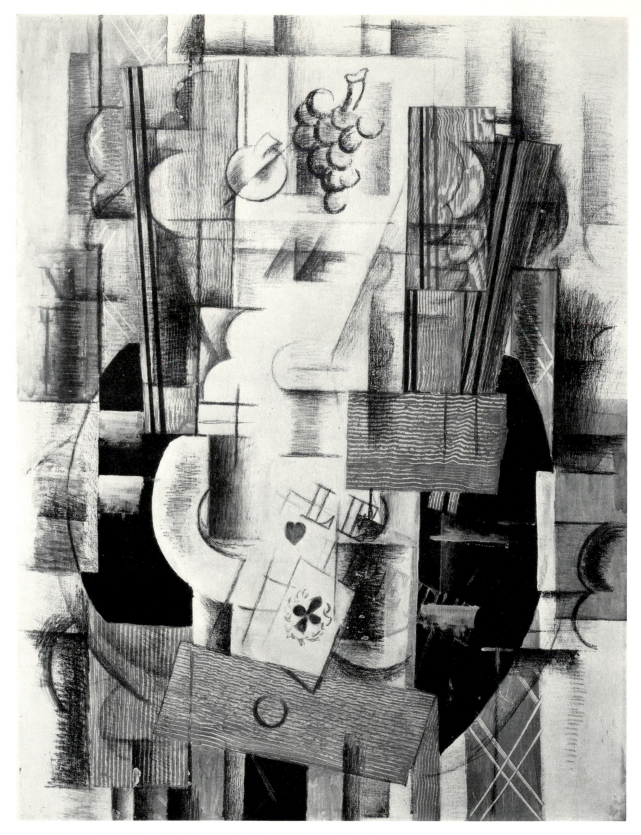

11 BRAQUE: Still Life with Playing Cards. *1912–13, oil and charcoal on canvas*

hundred years ago—known now under the name of "Constructivists."

My generation was not to stay in the Cubist camp for long.

The Cubist period of itself was a short-lived one, but it served as a steppingstone to a new ideological structure which we were beginning to erect around our sculptures and paintings. We have not incorporated that stone into our structure, we have left it outside in our memories as a reminder of an experiment that failed.

Continuing my discussion with the scientist, I draw his attention to a stone on my floor, and I tell him that I, in my experience of that stone, find that one particular characteristic of its image is its weight; I tell him that this experience of the weight of the stone is dominant in my consciousness of its image. I feel that weight so strongly that its pressure on the surface of the earth makes me wonder whether it does not displace the earth from its orbit, and as far as I am concerned, it might indeed do so.

I ask him how could I, an artist, bring into my work, a painting or a sculpture, that particular experience of mine—the experience of weight.

I say, "You will agree that many things in Nature possess that characteristic, and you yourself must have had first an experience of that weight just as I do, because you are dealing with it in your Art also.

"Can you tell me how to express this experience of mine and convey it to others?"

47

"That is easy," says the scientist; "weight is the force of gravitation. For a time we did not know exactly what gravitation is, but today, very recently, we can reasonably presume and show by our mathematical formulas that it is one more kind of wave—just like electromagnetic waves, or radio and light waves—and you may see that gravitation measured on a scale which will show you its quantity."

I do put it on a scale, and I tell the scientist that the image of that scale and the image of that which the scale is showing is another experience again, different from the experience I have when I look at this stone. What I now see by weighing that stone is a totally new image of another object which has its own identity, and as an object it has its own weight, and I am just where I left off—having an experience of another weight about which I want you to tell me how to convey it in my Art.

The scientist, annoyed at my ignorance of physics, tells me to try to lift it and then I shall know what he means.

I do try, and I cannot help having a new experience, a strain in my muscles, a tension in my body, the image of which is not at all identical with the image of that experience I had on looking at that stone. I tell the scientist that the lifting won't do; that after all, an engine of many thousand horsepower is very heavy according to his findings, but when it is in an airplane and I look at it in flight, I entirely lose the experience of its weight—to my vision of it, it is weightless.

And besides, I cannot ask everybody to heave that

Of Divers Arts
II

stone in order that they should share my experience of its weight.

I give him another example. There in the garden is a boy throwing a ball into the air, hitting a tree with it. This event I am watching makes an overwhelming impact on my consciousness as an experience—it conveys great beauty to me—it elates me to watch that ball hovering in the air on its path of rhythmic precision, and the movement of its flight is as much alive to me as when I see the flight of a bird. I find the vivid energy of the boy's hand continuing its life in the speed of the ball, and my experience of it is equivalent to the experience of the movement of living bodies; it is as real to me as my breathing.

Would you tell me, "What is this phenomenon of speed and how can I let others see and live through it as I do in my experience?"

"The speed of a moving body," says the scientist, "is its velocity, and velocity is the ratio of momentum to mass."

I reply that the words "momentum," "ratio," and "mass" are only symbols of his calculations, and have nothing to do with my actual experience. Symbols need a general consent in order to be regarded as typifying an experience or an event or an idea. But I have to transmit that experience in a visual image on a two-dimensional surface called a painting or in a three-dimensional object called a sculpture, and I have to do so without waiting for a general consent to the means I use.

Besides, neither I nor the people who look at my work

know what these monstrous symbols mean, since, according to your books, you scientists are yourselves in the dark about what they stand for.

The scientist brushes off my ignorant remark by telling me that this velocity enters into my experience as the change of position of the object in space.

I wonder, does not the scientist realize that he is dodging my question? My question is, just what is the image of that experience of the change of the ball's position in space which enters into my consciousness? He ought to know that no matter how many formulas he brings me for the physical forces of the boy's hand, the molecular elasticity of the ball, or the air resistance to the form and surface of the ball, they have nothing in common with that experience in my consciousness of the movement as an event.

A pair of events produces a third event whose image is entirely at variance with the image of those events and bodies which originate it. The third event has an image of its own, and its own identity has nothing in common with that of the previous ones.

I take a match and rub it on a box, and I produce a flame—each one of these three participants in that which is happening has its own image in my experience, separate and different from the others.

Of Divers Arts
II

The scientific means seem useless to me as an artist when I want to convey an image of my experience.

And here we stand, unfortunately, worlds apart [12].

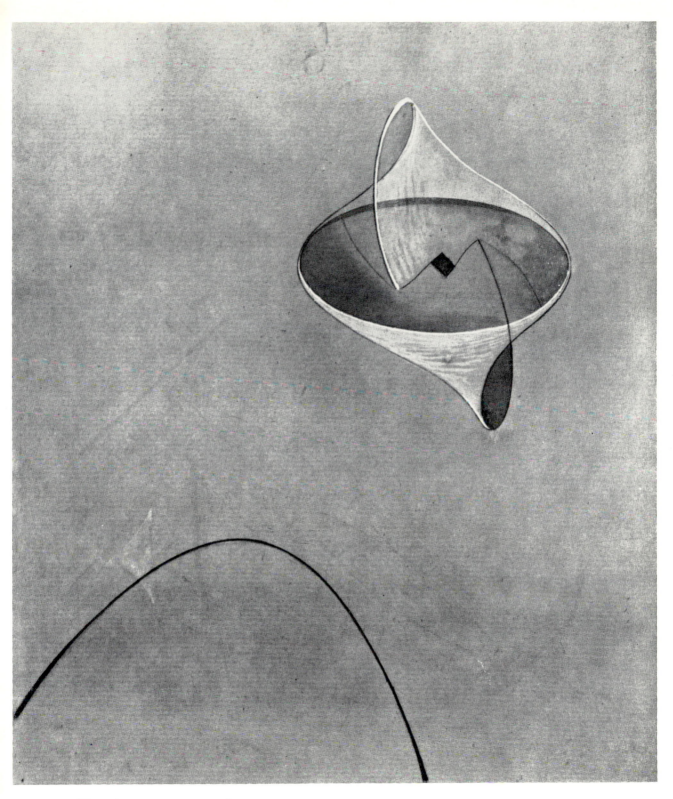

12 GABO: Hovering. *1940, watercolor*

I say unfortunately, for it does not need to be so. After all, we are both human beings, and our faculties for experiencing events of life and in Nature are identical. Our separation is only due to the fact that we look at the events from different points of view and for different purposes. But by doing so we are acting like those two legendary giants who, standing on the shore of an ocean, are involved in a dispute about whether the place on which they stand is where the land ends and the ocean begins or where the ocean ends and the land begins; all because one of them arrived at that spot sailing the waves of the ocean, while the other came on foot, treading the dry land.

We are in dispute because the scientist *observes* the world, thus separating himself from it and looking at it as an outsider. The artist, however, never really did *observe* the world, neither when he was an ignorant child nor at the time of his enlightenment when he produced the great chefs-d'œuvre left to us in the treasuries of our museums. The artist does not observe the world, he lives it, except perhaps when he listens to and trusts the scientist who tells him that the world can be known only through his observations; and you have seen what happened to him when he did that.

The scientist in his observation of Nature is looking only for an orientation in it. His aim is to handle that Nature and life. His purpose is to find the way to improve man's accommodation to his life and to Nature, and for

that purpose his consciousness has constructed a whole store of mental tools. He has invented symbols and signs to accomplish this task:

$$1 \quad 2 \quad 3 \quad . \quad . \quad n \quad \pi \quad pi \quad q \quad x \quad y \quad z$$

$$+ \quad - \quad = \quad \sqrt{-1} \quad i \quad \Delta \quad \int \quad \Sigma \quad \infty \quad \Theta$$

$$\sum_{i=2}^{\infty}$$

Here they are, and many more are being constantly brought into use when the old ones prove insufficient.

The scientist manipulates these signs and establishes general principles in the behavior of Nature; he constructs tables of mathematical formulas to give them generalized expression and incorporates them into his textbooks of physics, chemistry, mechanics, etc., calling them laws of Nature, whereas they are in fact only laws of physics, laws of chemistry, laws of mechanics, etc. For we do not know any laws of Nature so long as we are not participating with our consciousness in Nature's work. The laws we know are the laws of our conscious construction of the image of Nature. They are the expressions of that consciousness when it is in active participation in Nature's events, and we do not have the right to say, "This is how Nature

behaves." Nature does not behave—man tries to teach Nature manners.

In fact, what does the scientist do when he experiences in an object its length, its width and weight, or its movement? He starts to measure how long is the length, how wide is the width, how great the weight, how fast the speed. He takes a ruler and superimposes it on the length of the object, and sees that he can do this three times; he then concludes that the length of the object contains three rulers which he calls by the name of feet. He assumes that he has found out something about the length of the object. Whereas, if it were not for the convention that the scientists have established amongst themselves, that this process of measuring is concerned with the object, the scientist could, with the same logic, assume that his final result is concerned with the ruler, because it is the ruler that performed the manipulation, containing itself in the length of the object, three times.

Without the deliberate dictates of our consciousness in choosing the one in preference to the other for the benefit of the human art of action, the art of orientation, all scientific measurements would remain nothing else but

Of Divers Arts
II

measures of measures.

And that is what the scientist has achieved with his measurements. But he neglected the experience of all these phenomena in his consciousness, although it was that experience which was primary to his consciousness

before he started on the road of his calculations and measurements.

Without that primary experience, all the branches of Science, mathematics, physics, chemistry, and the rest of them, would not and could not be there. It is the boy who throws a ball and, without knowing any measures or formulas, hits exactly a chosen spot on the tree with a precision and a spontaneity that no machine can rival —it is he who is the original scientist, and not the man who grows up later on and calculates the trajectories of missiles.

It is the experience of length in every one of us when we see any object that inspires our minds to measure length.

It is our experience of the extensions of space which induces our mathematical explorations of distances.

It is the experience of the planets' movements that drives us to create geometries of their celestial orbits.

Science with its measures and its approach to Nature does not tell us anything about these phenomena, about our experiences which are the highest content of the whole of human existence.

We should have had no trouble at all, and there would have been no disputes between us, if the scientist ascribed to those signs of his which you have seen, to those symbols of his measurements, only the function they perform in the process of his observation of the physical world. But

the scientist does not stop there, he ascribes to them a deeper and broader meaning. They represent to him the whole image of Nature as he understands it and represents it in his Art.

The mind of the scientist is proud and presumptuous; it wants to force the world to move in strictly defined paths; it tends to confine Nature into a particular form and to give it one particular image which would fit into his scientific reasoning, in order to be more easily recognized by his scientific intellect.

But even that is not enough for the scientist; he wants Nature to have only the one image which he makes of it. He could not allow Nature to contain many of them. He does so because in the statute book of his intellect, his logic, there is a paragraph dealing with the rules of thinking, which says that "a statement which implies two contradictory meanings is nonsense," and therefore he concludes that Nature and life cannot at the same time be one thing and not be it by being something else.

But I, as an artist, trusting my experience, which is in no way different from the experience of the scientist, since there are no such things as a scientific experience and an extrascientific experience, I say that Nature and life can be just that.

Nature does contain and tolerate an unlimited number of images at the same time, and a statement about it can carry contradictory meanings and nevertheless make sense.

Of Divers Arts
II

In every sound there is silence; in every movement there is repose; in every thought there is an action, and any wish carries the seed of its fulfillment.

How could one of them be experienced by our consciousness without the presence of the other? Human consciousness can make of Nature an image of opposites and samenesses—an image of harmonies and disharmonies, an image of order and an image of chaos.

And I may remind the scientist of the fact that Nature is illiterate; it is ignorant of all that he has written on his scientific tablets, neither does it look at our pictures and sculptures.

Nature is not a chessboard, and we are not pieces moving on it in strictly defined order within strictly prescribed co-ordinates. The patterns of Nature can be as many as our consciousness is capable of drawing on it.

For there are no limits to human consciousness, and there are no boundaries to our experiences. And this consciousness of ours is forever here to grow, and the limits of our experiences through it are, therefore, bound to expand.

As our physical organism does not stand still, but is constantly growing, expanding its force and faculties owing to the invention of the art of the scientists, so our consciousness, too, is not standing still, but is in process of growing, and we are incapable of knowing to what limits in the far future that consciousness will develop and what

kind of images of the universe and of man's life this consciousness will be able to create. There must therefore be amongst us men someone to tend that growth, to see to it that it expands and strengthens, that it keeps pace with the immense and rapid growth of our bodily physique. For should that bodily growth of ours go on uncontrolled, it will inevitably become a cancer and the human creature a monster.

And here is where we artists, poets, visionaries, and dreamers come in. The scientist cannot do it by his scientific means alone, because Science has built up its means for a purpose which is not concerned with that which is our concern, namely, to give an image to the experiences of our consciousness, thus enhancing the growth of consciousness itself.

The scientist could indeed be of great help to the artist in his task if he, as a scientist, would listen more attentively to the voice of the artist in himself and to the artist outside his door as well.

Of Divers Arts
II

I accept the image of the world which Science is constructing, not because that image is the only true reality of Nature and life, but because it is a beautiful work of Art, perfectly performed. It conveys to me a new experience of its own kind, and I am as spellbound by it as I would be by any other experience from any perfectly performed work of Art. I would not miss that experience at any price; my own experience would be much poorer

without it, and I am eager to follow and await the newest accomplishments which it promises. But one thing I am not prepared to grant to Science, namely, its demand for sole authority to judge what is true and what is false in the images of life and Nature which Art in general, apart from the scientists, is trying to create.

I, the artist, am not only a spectator, not only a reader of the harmonious poems of Science—I am an image-maker myself. But what I am trying to convey in my Art is something of my consciousness that is neglected by Science, and for which the means of Science are of little avail to me—I make my images with my own tools and means, and what those means are, how they work, and what I am doing with them, I hope to tell you when we next meet.

III

I AM AFRAID that I shall have to start my discourse with a commonplace statement, almost a platitude, and that is that an artist, in making a sculpture or a painting, is forming it in visual terms. His consciousness is tuned to the events in the world through vision, and he is incapable of expressing his experiences in any other but visual terms.

Of Divers Arts
III

It is equally impossible for the spectator to perceive the image in a painting or a sculpture in any other way but in visual terms.

Whenever any other of the five senses accompanies our visual perception of objects, whether in Nature or in

Art, they are only derivative from the dominant sense of vision, extraneous to our visual experiences, and they act only as a resonance to the visual sense.

I would not need to mention this seemingly obvious fact were not the public prone to disregard or forget it. More often than not, they expect a painting to speak to them in terms other than visual, preferably in words, whereas when a painting or a sculpture needs to be supplemented and explained by words it means either that it has not fulfilled its function or that the public is deprived of vision.

It is for this reason that a thorough understanding of the process of our visual perceptions is essential to the appreciation of the vision of the world in our ordinary everyday life as well as in the work of the artist.

We have to distinguish between two faculties which are in action when we see things: the physiological faculty of sight and the conscious faculty of vision.

Sight is only a vehicle by means of which we receive the visual signals. Vision, however, is what our consciousness makes of these sight-signals.

An optical sensation which has not passed through our consciousness is a blind reflex. To explain what I mean by this I will give you an example:

We are sitting at a table, and we are doing something with our hands, say, writing. On our table there are many different objects, not only the paper and the pen in our

hands; there are books, pencils, an ashtray, cigarettes, some flowers in a vase, and other objects. Our eyes very often wander about the table, away from the paper on which we are writing; quite often we look at the objects and our sight certainly registers them all, but we have no vision of them; so much so that when we suddenly need a knife, which is also on the table, we cannot find it, although "if it were a bear it would bite us!"

Only when our consciousness is concentrated on distinguishing one particular object from the others—only when our consciousness has fixed an experience of that particular object in its own distinct image—only then do we have the vision of it.

That vision differs from the optical process which operates in the physical structure of our eyes, in being the result of an operation of our consciousness and not only a sensuous reflex. Vision, therefore, is an operation which takes place in our consciousness, being the final stage of our whole visual conception of the world, whereas our sight can be defined as a latent faculty within us which remains inert so long as our consciousness does not make use of it.

Of Divers Arts
III

Science has dedicated a great deal of effort to investigating the mechanism of our sight. It has developed comprehensive theories about how to utilize the laws of optics in reproducing the image which our sight reflects on our retina and how to apply them to the investigation of many

other phenomena in Nature. But Science has left out of its investigations the essential faculty of our consciousness of perceiving the world not by sight alone but by how it constructs a visual image and what it makes of sight's reflections.

Those who are not artists by vocation and have, therefore, no particular urge to transfer the images of their vision into pictorial or spatial terms do not need to search for the means of communicating these images. But for the artist these visual means are of vital importance, and from the very beginning of painting and sculpture, the artists of all ages have been intensely preoccupied with the search for understanding the ways and means they have to use to transmit their visual experiences onto a two-dimensional surface or into a three-dimensional sculpture. It is not the purely technical problems which were and are the center of their concern.

The actual manual operation of making a painting or a sculpture is easily learned. Whether an artist, being a painter, takes a stick and makes a drawing with it on sand or whether he uses pigments or the actual material to convey a color; whether the primitive sculptor takes a piece of wood and whittles it with a sharp stone or a contemporary sculptor, like myself, operates with up-to-date machines—all these technics are of little import to the purpose and content of a painting or a sculpture and its images.

I can make a sculpture with the rays of the sun and I can make one with the dried peat from a bog. The material I shall use, in that case the rays and the peat, will be impelled on me by the image of my experience which I sought to transfer to the sculpture; and the materials, once chosen, will in their turn dictate their own technic. At any rate, it has already been established by many students of art history that the technics of making a work of pictorial or spatial art are usually identical with the technics we have and apply for utilitarian purposes in accordance with the level of the technology of the time the artist lives in.

Now let us see what are those indispensable visual means which make up the image of the objects we see in ordinary life and the image of that which a painter or a sculptor transfers to us in his work.

By the words "visual means," I have in mind those attributes of our consciousness through which a visual experience of anything we look at is conveyed to us, so that we can recognize the visual identity of an object and distinguish it from other objects.

How do we conclude that we have recognized an object's visual identity so clearly that we can and do use a symbol, such as a word, a name, for it and can be sure that we shall be understood by others?

For instance, what gives the word "chair" the faculty of carrying back to our consciousness the visual memory

of the object "chair"?—surely not only the thought of its function; not our knowledge that a chair is an object which we use to sit on, as some logicians insist on saying, since the action of sitting is not the main characteristic of the visual image of a chair. We may take a seat on a log of wood or on a rock in a field or on a stair in a house, but we will not call these objects "chair." In our consciousness they remain visually a rock, a log, a stair, but not a chair.

So there must be in our consciousness a visual memory connected with the identity of some chair, and this evidently is not and cannot be anything else but the formal configuration of the object in space, i.e., its image.

The constituent parts of that configuration are the lines of its contours, the shapes which these lines enclose, the colors and textures of its surfaces, and the forms its volumes occupy in space; these are the fundamental visual means which our consciousness uses to construct an image of an object.

These are also the same means that human intelligence uses when it wants to communicate anything in visual terms; it operates in every one of us in our everyday visual perception as well as in our communications, and not only in the pictorial art created by the artist but in all fields of the exchange of knowledge—including, of course, pure Science as well.

But as many things are more recognizable by contrast than by similarity, so in this respect it is instructive to see

the contrasting roles those primary visual elements play in visual art and in the art of Science.

The scientist restricts these elements within the limits of his own generalizations convenient to his calculations and measurements. He looks at an object for the sake of measuring it, and defines a line as the distance between two points, the shortest such distance being a straight line. (This Euclidean definition is still valid today in spite of the modern geometry of Riemann and Einstein's idea of the curvature of space.)

A line to him is either a straight line, a curved line, or a broken line, and their interrelations are kept within strict characteristics alone: parallel, intersecting, converging, or diverging.

You can count the number of basic *shapes* the scientist uses on the fingers of one hand: the square, the circle, the triangle, the ellipse—and the same goes for the three-dimensional *forms*: cube, cylinder, cone, sphere, and their compounds.

All regular geometric figures and shapes are to the scientist forever circles, triangles, squares—no matter what their dimensions, whether they are in space and what they are made of. In the scientific representation, these shapes are nothing else but idealized, synthetic generalizations of all the visible forms in Nature, and they serve exclusively as a measure; they are confined by the scientific mind within strict mathematical laws, and they

Of Divers Arts
III

66

are defined by exact characteristics which are valid for all of those in each group without exception. As such they are, in the scientist's mind, only abstract symbols.

In the field of his scientific observation, and in the logic of his geometries, these generalizations are true and valid inasmuch as they attain the purpose which the scientist sets himself, namely, the quantitative measurement of the object of his observation. But quantitative measure is not the artist's goal. His task is to form an image of his visual experiences in visual terms by visual means alone, and in that process these means play an entirely different part from that which the scientist assigns to them.

No one of the generalized characteristics, no one of the laws which the scientist has discovered, has any validity or significance in the artist's vision of the world or in his representation of his visual experiences.

For the artist, a drawn line is not a distance between two points, but a direction, a path, by which his visual experience follows the movement in the line. That movement does not need to be, and as a rule is not, the actual movement of that line in space or on a surface. It is an inward movement of our consciousness in its process of conveying a visual experience of that line—it is a tracing of that action of our consciousness in its perception of a line. For no action of our consciousness in producing an experience is ever static: it proceeds in time, it moves in

time. In the artist's vision there are no limits to the directions, bends, and undulations of a line's movement.

In the same way there are no boundaries in the variety of shapes other than the boundaries of their own integuments; there are no other frontiers to a three-dimensional form except those with which its lines and shapes constrain it in space or on a surface.

No two shapes or forms, be they geometrically regular or freely drawn, even when they are mathematically equal, are ever equal to one another in their effect on the artist's experience. They do not acquire their singular character by the generalized laws of mathematics, but they gain their identity from their relation to other forms in the field of the artist's vision, carrying pictorial meaning by their own existence, which is unique in each of them; and each produces its own individual psychological effect on our experience. They all act as events, and our perception of them is not replaceable by any other means at the command of our spiritual faculties. It is impossible to comprehend the content of an absolute shape, absolute line or form or color, by reasoning; they can only be known by our experience of them, and their influence on our psyche is unique—it can break or mold it. Shapes, lines, and forms can exalt or depress, elate or cause despair; they bring order or confusion into the state of our minds; they are able to harmonize our consciousness or to disturb it; they possess a constructive power or a destructive danger.

Of Divers Arts
III

In short, lines, shapes, forms, colors, have all the properties of a real force with a positive and negative direction.

In the artist's hand, when he transfers an image of his experience into a painting or a sculpture, these means are no longer scientific abstractions but concrete forces in action.

The image of an object which the scientist conveys and the image which the artist creates differ from each other in this respect: that the scientist uses as symbolic abstraction the means we have described, referring his image to reason, whereas what the artist makes acts immediately on our experience in the same way as does the object or the event itself.

And now I should like to show you some pictures which are meant to illustrate what I am talking about [13–29].

15 Animals and figures. *Mesolithic rock paintings, Bacinete, near Los Barrios, southern Spain (copies by the Abbé Breuil)*

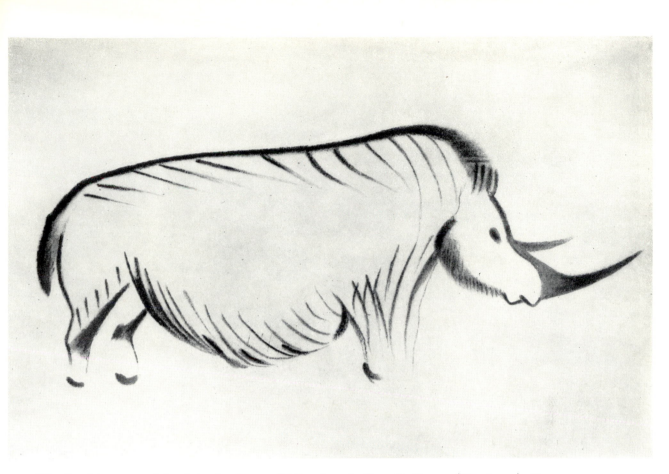

14 Woolly rhinoceros. *Magdalenian cave painting, in red, Font-de-Gaume (Dordogne), France (copy by the Abbé Breuil)*

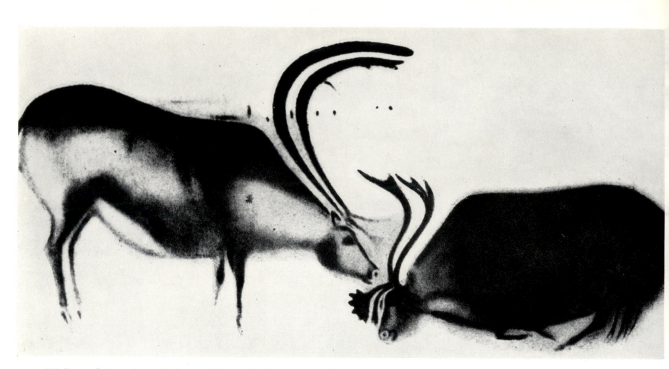

15 Male and female reindeer. *Magdalenian cave painting, in polychrome,*
 Font-de-Gaume (Dordogne), France (copy by the Abbé Breuil)

16 Bison. *Magdalenian cave painting, polychrome, Altamira, northern Spain*

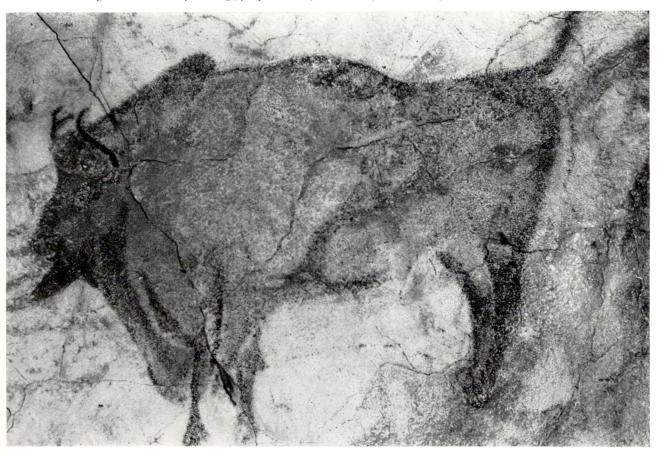

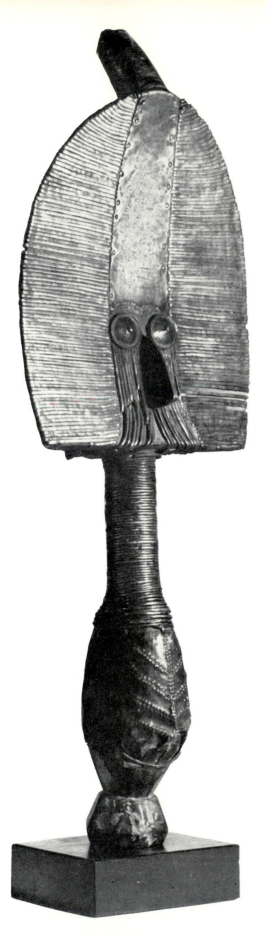

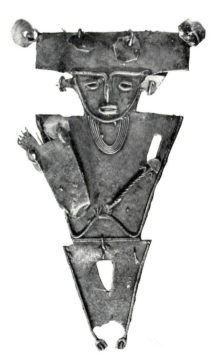

17 Funerary figure, "Bieri." *Osheba, Gabon, wood covered with copper strips*

18 Anthropomorphic figure, "Chibcha." *Muisca style, Tunjo, Colombia, gold*

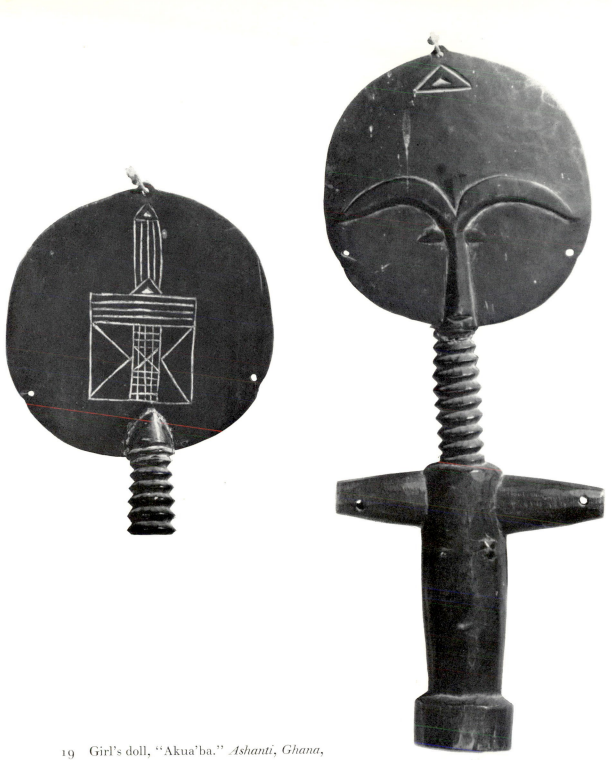

19 Girl's doll, "Akua'ba." *Ashanti, Ghana,*
carved wood (front and back)

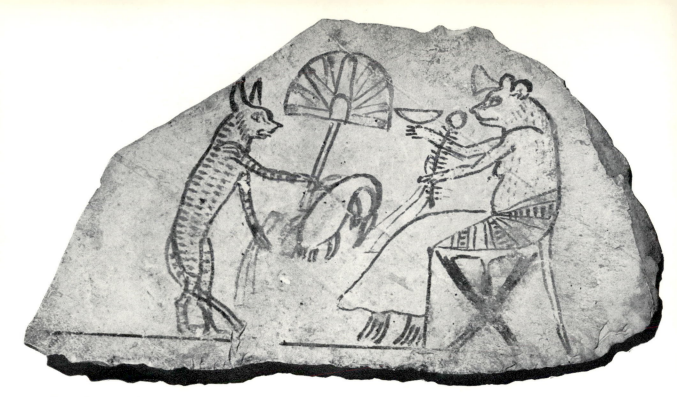

20 Sacred cat serving a mouse. *Egypt*, XVIIIth *Dynasty,*
c. 1570–1345 B.C., *painting on a limestone fragment*

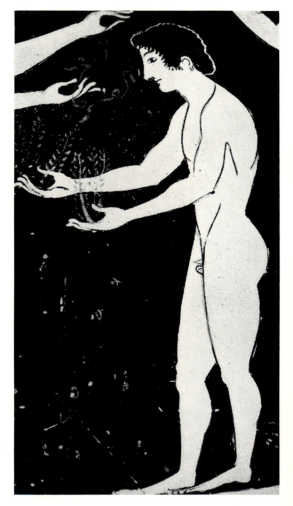

21 Athlete receiving the crown of Victory.
Detail from a red-figured Athenian psykter,
c. 520–510 B.C.

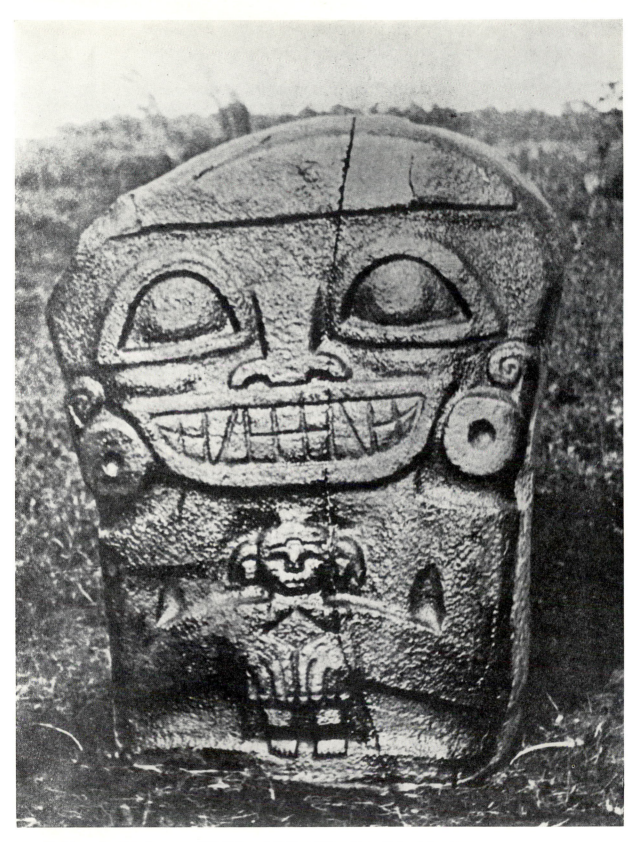

22 Goddess showing her son, "El Cabuyal." *Pre-Columbian, Colombia, stone*

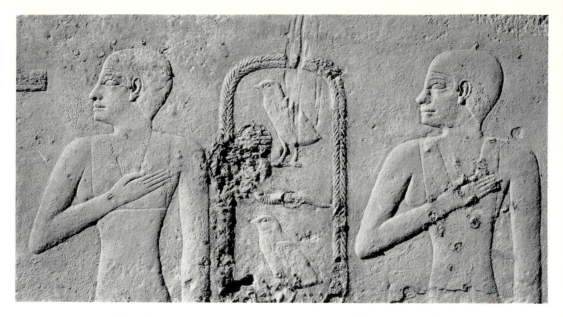

23 Two descendants of Cheops. *Egypt, IVth Dynasty, c. 2690–2560* B.C., *relief fragment from Giza, limestone with accents of green paint*

24 Horus Falcon with King Nectanebo. *Egypt, xxxth Dynasty, c. 359–341* B.C., *from Heliopolis, basalt*

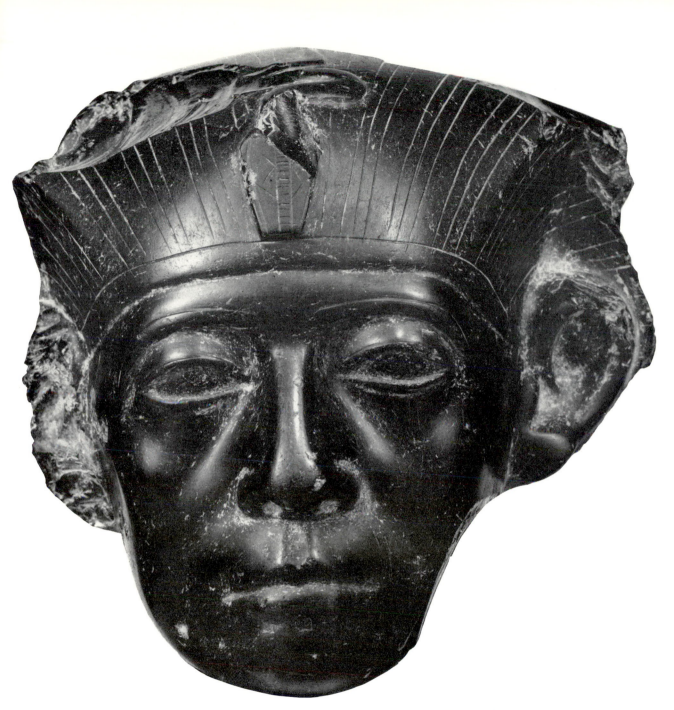

25 Head of Amenemhat III. *Egypt,* XII*th Dynasty, c. 1990–1778* B.C., *obsidian*

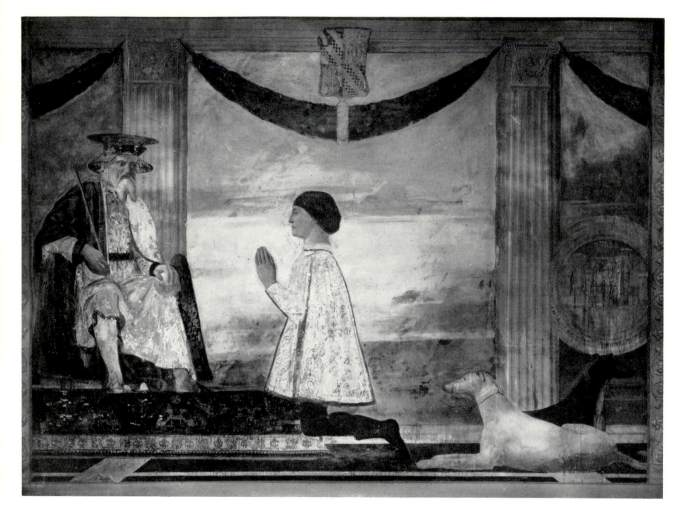

26 PIERO DELLA FRANCESCA: Sigismondo Malatesta Kneeling before His Patron Saint.
Fresco, XVth century, S. Francesco, Rimini

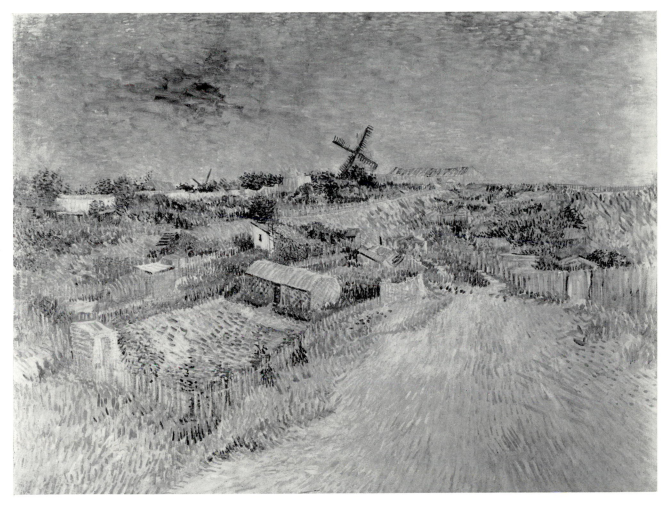

27 VINCENT VAN GOGH: Little Gardens on the Butte Montmartre. *1887*

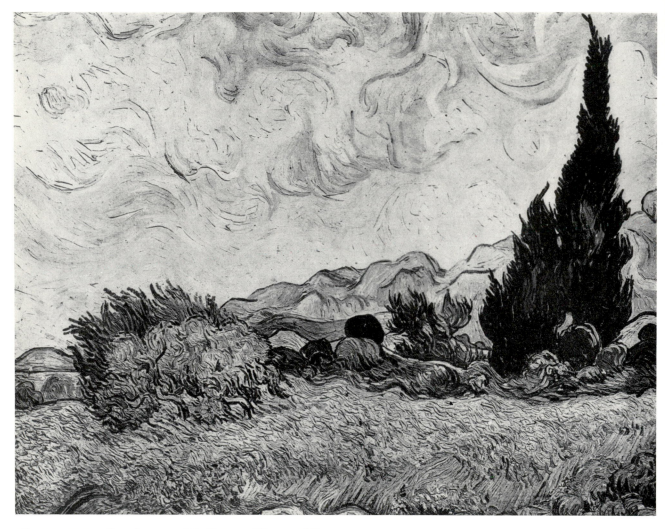

28 VAN GOGH: Landscape with Cypress Trees. *1889*

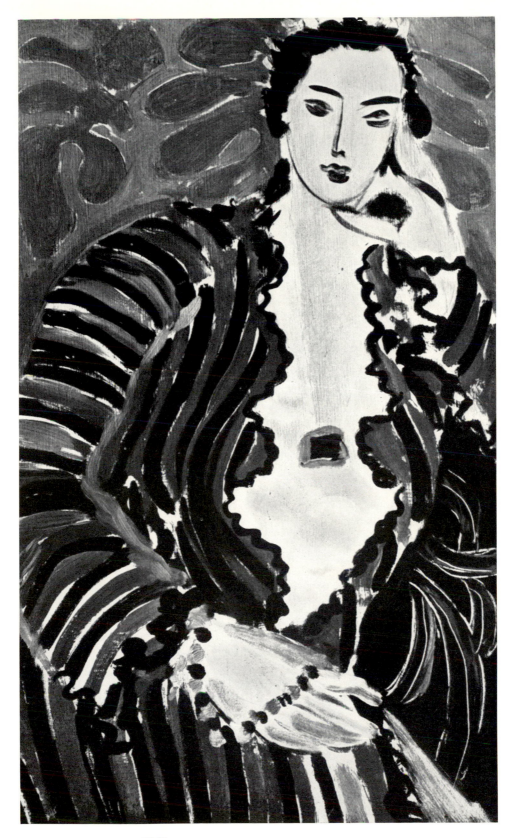

29 HENRI MATISSE: Hélène. *1937*

IV

THE ILLUSTRATIONS we have just seen may perhaps clarify how pictorial elements—lines, shapes, forms—have operated in the visual expression of the artist from the very beginning of painting and sculpture up to our own day. They show how the lines, shapes, and forms gradually developed through the visual consciousness of the artist.

But I must add something more than just the mention of color as an element. I could perhaps limit discussion about color to the simple statement that all textbook theories about colors are concerned with their chemical and physical properties and have no relation whatsoever to their aesthetic nature.

Of Divers Arts
IV

An artist can be absolved from the necessity of knowing all that the scientist knows about colors. Except for some practical information which it is necessary for him to have about the treatment of pigments and materials, the scientific knowledge of their chemical and physical properties is apt to confuse the artist more than to enlighten him in his art and to distract him from knowing what his experiences of color are.

On the other hand, since the speculations of aestheticians are based on the premise that there is such a thing as a science of Art, and I firmly believe that there is not and cannot be such a thing as a science of Art, but there is and can be only an art of Science, I should perhaps refrain from any aesthetic speculations.

But I should not be truly fulfilling my task were I to limit myself to these remarks only about so important an element as color in the creative process of an artist. However, if I share with you the conclusions about colors at which I have arrived in my dealings with them, it might be of some use to the artist in his work as well as to you in your appreciation of it.

I would like first to bring you back to a particular artist, whose work I have already shown [27, 28]. He cannot be accused of being speculative in one of the remarks he made about his own paintings.

In a letter to his brother, van Gogh describes in detail the landscape he saw from his window, looking on the

park of the asylum where he was staying. He says, "You will realize that the combination of red ocher, of the green gloomed over by gray, the black streaks surrounding the contours, produces something of the sensation of anguish, called 'rouge-noir,' from which certain of my companions in misfortune frequently suffer. Moreover, the motif of the great tree struck by lightning, the sickly green pink smile of the last flower of autumn serves to confirm this impression." And he concludes his remarks with the very pertinent statement: "I am telling you about this canvas to remind you that one can try to give an experience of anguish without aiming straight at the historic Garden of Gethsemane."[7] [30]

Of Divers Arts
I V

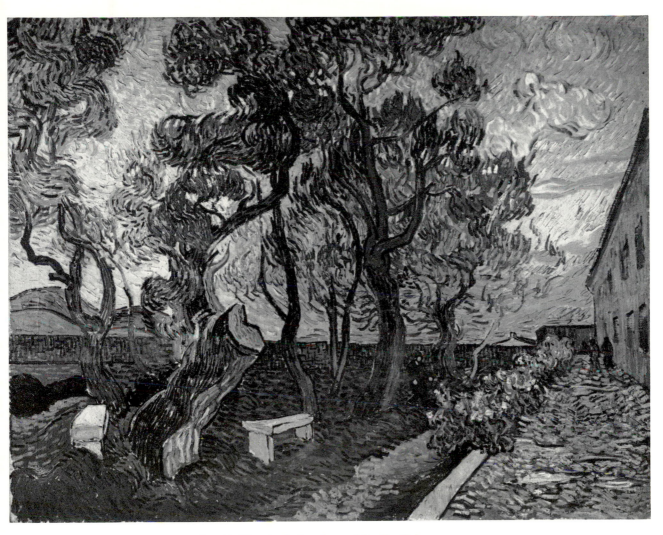

30 VAN GOGH: The Park of St. Paul's Hospital, October 1889, St. Rémy

This last remark and the previous one about "the combination of red ocher and green gloomed over by gray" seems to me one of the most profound insights and revelations of what color means to the vision of an artist. You may note that van Gogh was not what we now call an abstract artist. He was dealing with landscapes, trees and grass and fields, and was drawing them from Nature, recognizably, naturalistically. And yet the colors he experienced in that landscape had in his vision an existence and a force all their own, independent of the object, and he also draws our attention to their psychological effect.

This is exactly what one should keep in mind in the appreciation and understanding of the role color plays in our vision as well as in works of art. You cannot generalize about the experience we get from colors.

Science tells us that there are only seven basic colors of the rainbow in our ordinary vision. For sunlight, this dictum is true only in so far as it relates to the physical structure of light and in so far as it fits into the frame of the scientific thinking in observation. It provides the scientist with a scale of measurement in his analysis of optics and his investigations of the structure of light; the simplicity of that scale affords him a handy tool for generalization, but it is of no avail for the artist in his field of visual experience. In fact, it does not operate even in the visual experience of the average human being; that scale cannot

reveal what is going on in our consciousness when we see a color.

There are no general terms for any color. In the visual experiences of our consciousness, black, for instance, is not the absence (by absorption) of the seven visible colors of the spectrum, as science defines it. Obviously, such a definition fits any other color of the spectrum when we observe it isolated from the rest of the spectrum's colors; therefore, it defines nothing about our perception of black as a color. The scientific fact of absorption does not prevent us from having a vision of black as a positive color in its own right equal to any other color. Many of our dreams are dreamed in color, including black; and dreams, as all the scientists of today agree, are not phenomena outside our consciousness.

Neither is the scientific definition of white as the reflection of all seven bands of the spectrum valid in an artist's vision. I have yet to be shown in actual fact the white of snow produced by mixing those seven bands of the spectrum. In the same way, the white of snow and the white of a cloud on a sunny day are not the same white as the white of a piece of Carrara marble or the white of a chrysanthemum; each of them conveys a different experience of white.

I should go out of my way were I to attempt to explain in words the multitude of attenuations that a color carries into our visual experience. I can do it only by some indica-

tive examples from some of my own work, prefacing them with this observation:

What kind of image comes to our consciousness when we say "red"? To a scientist in his laboratory, red is only one thing, the stripe produced by the longest waves on the visible band of the spectrum of light. To me, to you, as well as to the scientist as a human being, when he gets his experiences of color from life and not from his spectroscope, it may mean either nothing at all or an endless chain of images of a multitude of color experiences [31–33].

Of Divers Arts
IV

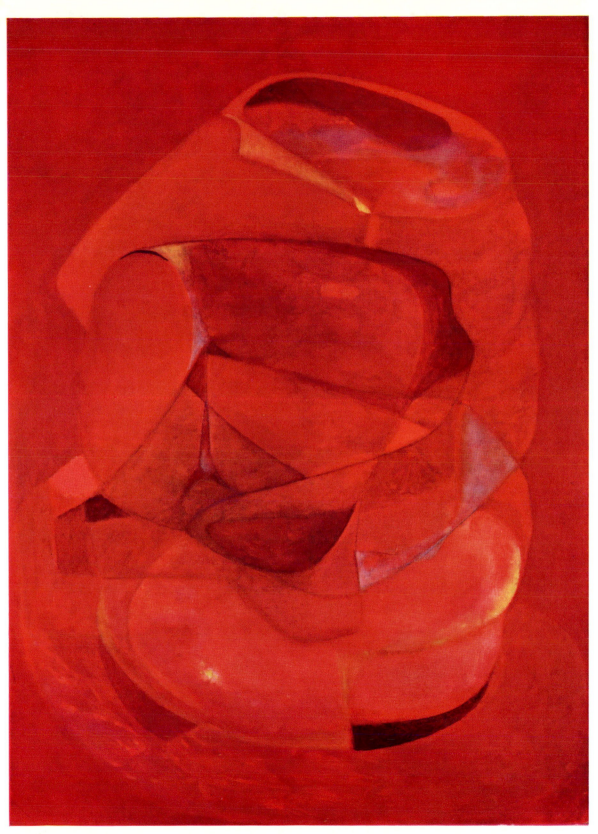

31 GABO: Glowing. *1946–60, oil on wood panel*

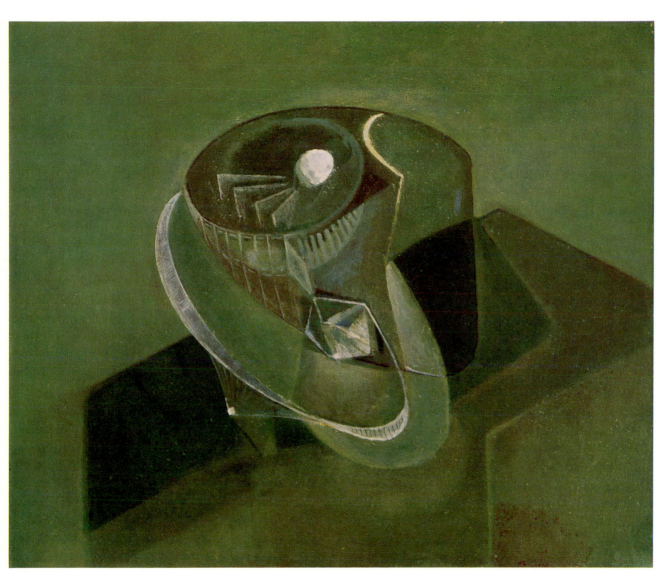

32 GABO: Green Painting. *1944*

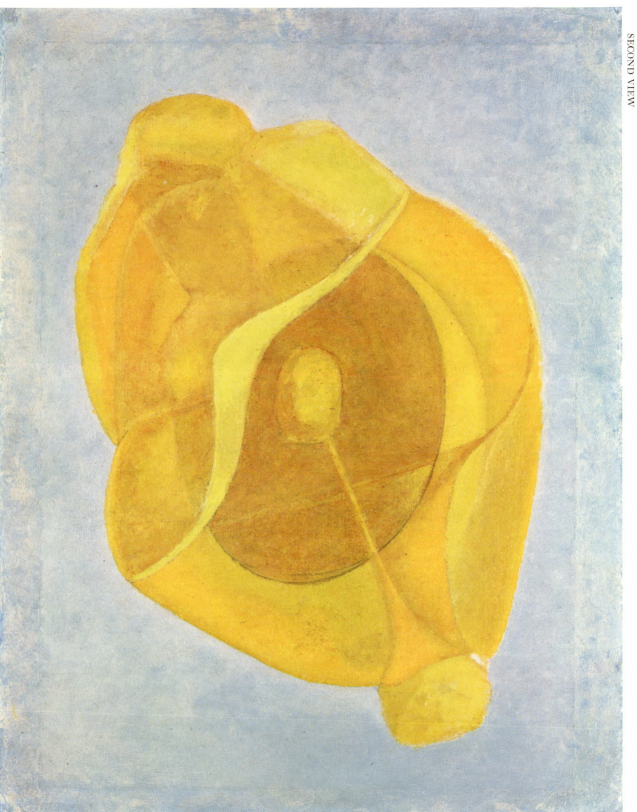

33 GABO: Yellow Painting, "Strontium." *1945. This painting
is meant to be viewed from all four sides*

Of Divers Arts
IV

All colors, even in their seemingly identical hues, have a different identity in our vision of them. One and the same color acts differently on different surfaces. Colors change with the change of their place in space or on a surface, and their identity also varies with the time at which they appear in the field of our vision. They change not only according to the neighboring color—a fact by now known to every schoolboy—but in relation to the frame of our vision and its axis, i.e., to right or left of the axis, and up or down from it [34].

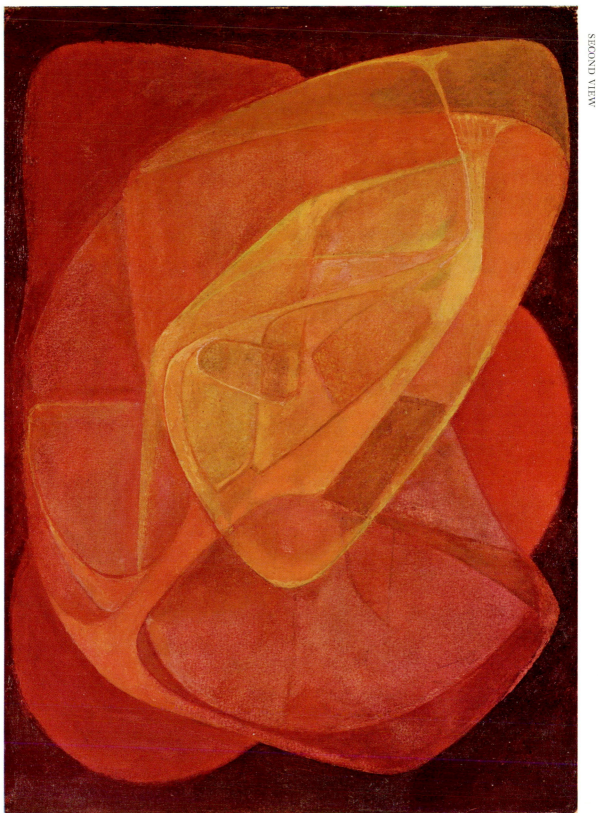

34 GABO: Red Kinetic Painting, *1943, oil on board panel.*
This painting is meant to be viewed from all four sides

Color affects the bounds of the shape in which it is enclosed and changes the form of surrounding space; it modulates distances, retards or accelerates the rhythm of our visual perception.

Color is the flesh of our visual perception of the world, not its skin. A visual experience of color is never flat, it is enveloped in light, permeated by light; and wherever light is there is space.

It is not due to sheer abstract reasoning alone that the Science of today makes light the basis of all its mathematical calculations in constructing the new image of space. It is, rather, because lightless space is meaningless, and in that case our consciousness guides us only to grope in circles. This may be a better explanation of why the scientific image of space today is a curvature.

That brings me to the phenomenon of our experiences of space. I fear that the mere mention of "space" will evoke in your minds the now common idea of traveling to the moon and the planets with all the paraphernalia of gadgets, fantastic engines, and the rest, which our newspapers and magazines are continually printing pictures of, to illustrate the idea of space. Popular as this has become, I will ask you to forget it all if you want to follow what I have to say about space in an artist's visual experience.

The phenomenon of space-experience about which I am speaking is something so down-to-earth, such an inseparable part of all our everyday experiences, that for a

Of Divers Arts
IV

98

very long time we all, artists included, have taken it for granted as self-evident.

The experience of space has been with us and with the artist throughout the whole history of Art—a reality in our vision of the world—and its role was that it accompanied all objects and all events. The objects and the events happened to exist and to occur in space. When we study the history of painting or sculpture, we find that the artist left space to the observer to fill in automatically for himself.

In painting, space appeared much later on when the artist learned to present the world as it is reflected in his eyes. The feeling of far and near in the painting was automatically there, accompanying the objects which were painted according to the laws of optics and the reflection on our retina which the scientist had taught the artist to represent by perspective.

Sculpture, from its beginnings, dealt with closed volumes and compact materials alone, so space was of no concern to the sculptor, since the solid had a space in which it stood, and that was the whole function of space in the plastic arts up to very recent times.

It is only with the appearance of the constructive ideology in art that space has become of special concern to the sculptor and the painter. In the *Realistic Manifesto*, published in Moscow in 1920, there was a clear call to the artist to use space as a new pictorial and plastic element amongst the other visual elements, assigning to it the

same importance that lines, shapes, and colors have, as basic means in the structure of a visual image.[8]

But the word "space" on that occasion carried a totally different meaning from that which it had for the scientist. It did not carry some sort of transcendental and abstract idea about space; it is a concrete element of our vision, playing an active role in the structure of an image in a painting or a sculpture.

Space in our vision is not the distance between far and near, not the above and below, not even the place which is there or here; it is penetrating, everywhere present in our conscious experience of vision. We are not interested in its material substance, or in its configurations as a generalized entity embracing the universe. Space is an ever-present reality in the visual experience of our world, without which no full image of anything can be conceived. It is ever within our reach, and thus it carries an experience of palpability equal to any conveyed by the tactile sense. In short, in a constructive sculpture, space is not a part of the universal space surrounding the object; it is a material by itself, a structural part of the object—so much so that it has the faculty of conveying a volume as does any other rigid material.

Apart from space, the constructive ideology introduces another element into visual Art, the element of time; and here again this element in the artist's experience is not that static sequence of intervals measured by days and hours of past and future, it is not the mechanical phenom-

enon we measure by our clocks; neither is it that idea of contemporary science where it has become a relative term dissolved entirely in the idea of space-time so that both become one. Time to us is the faculty of experiencing the continuity of the present.

Ask the scientist what is time—he will show you a clock and will tell you that if you go on an interstellar voyage at the speed of light, your time will contract and you may return still young to your greatly aged earth.

That may be a crude interpretation of the scientific image of time. One has to read that scientific poem in its own mathematical language to perceive the beauty and sense of its image. But it is not the image of the experience of time that I, as an artist, have. My image of the duration of time is measured by the intensity of my experience of it. The reality of that experience lies in the fact of our being conscious of the duration of an event. The scientist measures it by the signal emitted by a clock (be it mechanical or otherwise), and this measure is valid within the conception of time in his observation of events; it provides quantitative values for the symbol t in the mathematical equations he creates to measure events with regard to their incidence in the world outside our own being. But that scientific measure is not valid in any other art. Where the artist is not concerned with quantitative measurement of time but with the quality of his experience of an event's duration in his consciousness, a lifetime's duration may shorten to nothing, and a moment's experience may have

a span of time lasting without end and having no beginning.

This does not at all imply that such a notion is applicable only to the artist's experience: it is a measure which has to be applied to all conscious human experiences. We neglect that measure in our reactions to life's events owing to the practical pattern science has imposed on our everyday experiences of life.

The rhythm of the duration of an event is an experience of our consciousness whose beginning and end is not determined by the clock but by its duration within our consciousness, and once there, it has no other dimensions and no other limits save the limits of the experience itself. Time becomes, in that case, a part of our consciousness where minutes and seconds and days and years have no meaning. It is a presence without intervals, since in our consciousness the intervals themselves are events and are experienced by their duration.

An artist, in making an image of his experience of an event, has to bring this experience of time into it if he wants the image to convey the experience of life in that event. And what I mean by that is to carry the experience of its happening to the spectator in the image he is creating of it.

My explanation of the function of space and time in the visual experiences of the artist may perhaps be clearer to you in the work to be seen in the following illustrations [31–42].

Of Divers Arts
IV

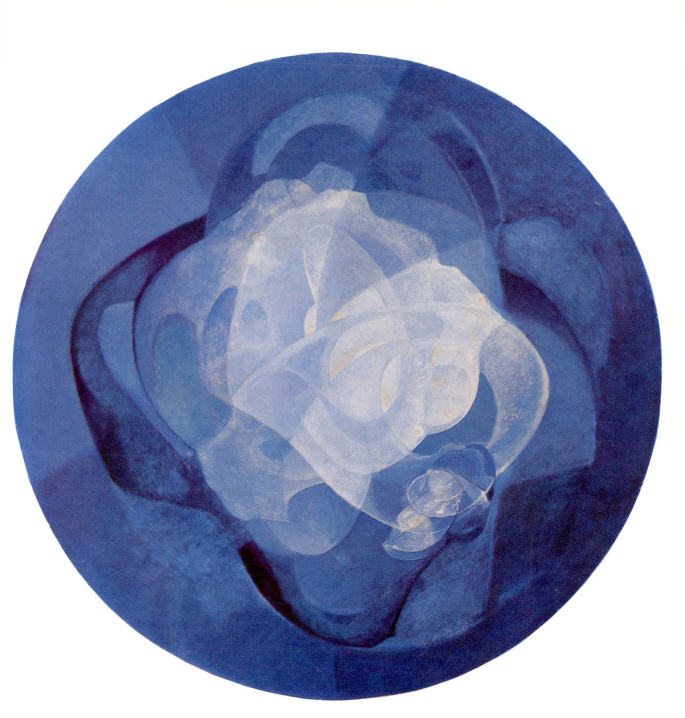

55 GABO: Blue Kinetic Painting, *1945–54, oil on wood panel.*
This painting is meant to be viewed in rotation. The panel is
mounted on a motor making one revolution in two minutes

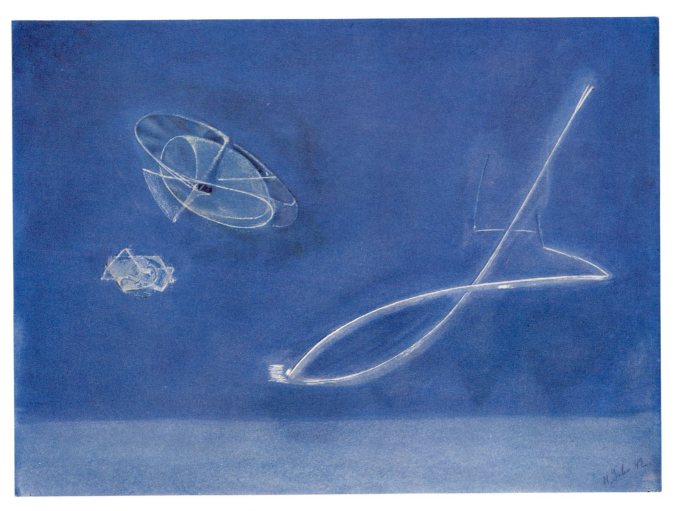

36 GABO: Blue Painting, "Carbis Bay." *1940–45, oil on paper*

37 GABO: Linear Construction with Red. *1953, plastic, aluminum, and stainless steel*

38 GABO: "Logan Rock," study for a sculpture. *1933, oil on wood panel*

This screened reproduction of the view in 39a, omitting only the shoulder details, illustrates the advantage of the stereometric system. In a constructed sculpture space is used as a material part of the image, allowing the artist to convey several aspects of the same image in one and the same volume.

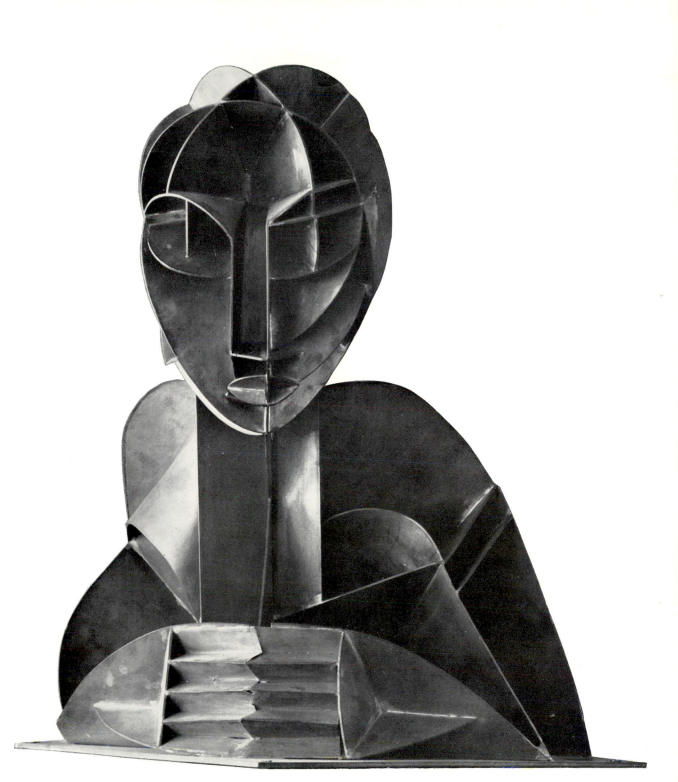

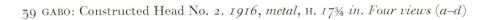

39 GABO: Constructed Head No. 2. *1916, metal*, H. *17¾ in. Four views (a–d)*

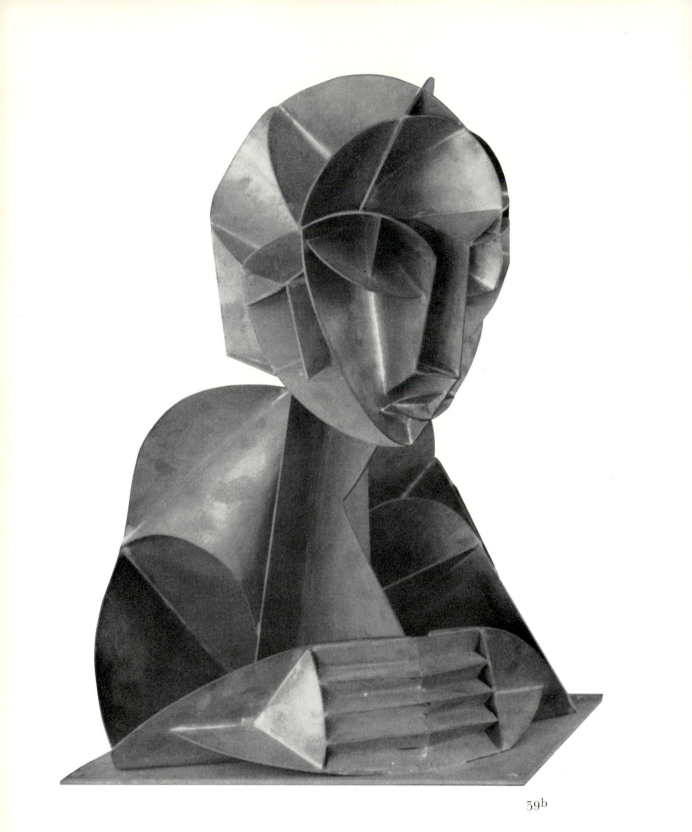

39b

39c

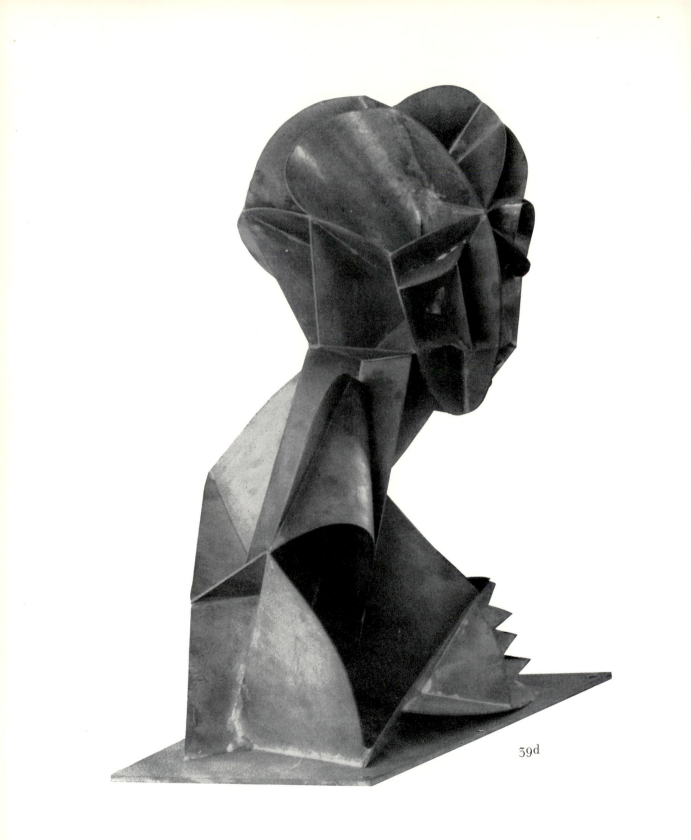

39d

40 GABO: Carved Stone. *1949*. D. *9⅝ in. Two views*

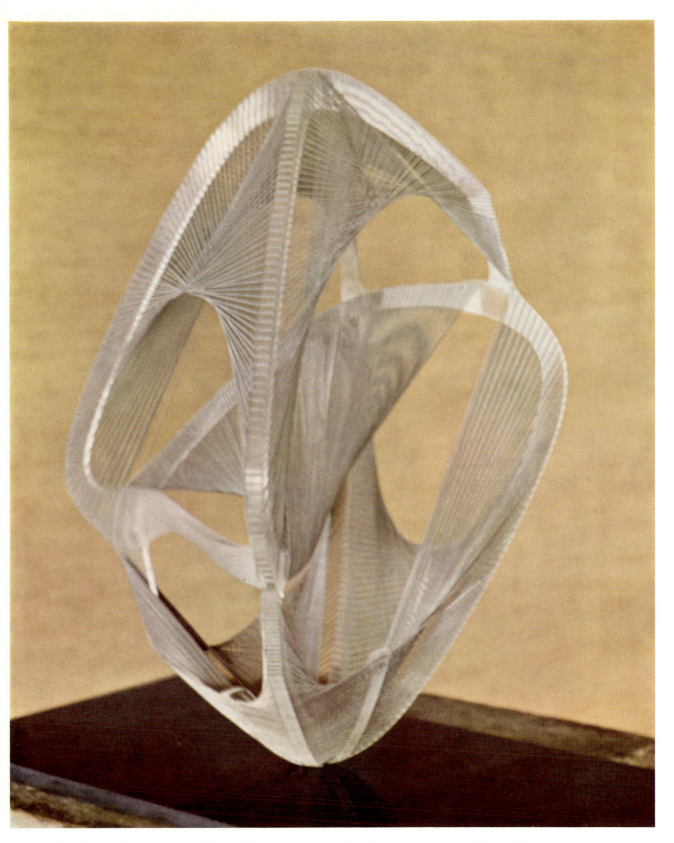

41 GABO: Linear Construction No. 4, white. *1959, plastic, aluminum, and stainless steel*

V

FROM THE CONSTRUCTIVE sculptures and paintings which I have shown you, you may have gotten the impression that they, having no discernible associations with any objects of nature known to you, represent some kind of abstract idea the meaning of which the artist has hidden in a language comprehensible only to himself. I must, therefore, dispel such a notion by assuring you that such an assumption would be erroneous.

You have been educated and have gotten used to looking for something in a sculpture or a painting which you have already seen and can recognize even when it is represented by the artist in a new form, and when you see a

work of art in which the artist does not even attempt to represent an object already seen by you and you do not find what you are looking for, you call the work abstract and complain that you don't understand it.

You forget that you would not ask for a pound of nails in a baker's shop. Constructive art (which is also falsely called abstract) does not intend to represent an object or a view of the world already seen and known by you. It aims to convey to you the visual image of an experience, and the visual image of an experience of an object is something different from the object itself; it is an event in our consciousness, and our consciousness allocates to each event a different existence in space and time.

This dual existence does not carry contradictions in its meaning if you keep in mind that both the image of experience and the image of the object are creations of consciousness, and it is characteristic of consciousness that it allows such dualism. This is why, in my view, it is totally false to call a work of art the purpose of which is to convey the image of an experience "abstract," whereas you call a work of art which gives you the image of an object "realistic." Both of them, if you wish, can be legitimately called abstractions, since they are both images created by our consciousness, while in actual fact they are both realities.

When looking at an image of an experience which an artist conveys, there is no need for you to look for some

meaning other than that which you automatically find in your consciousness when you look at a landscape or anything which you see in the world. The image of the landscape comes to your vision by means of the formal configuration which your consciousness creates. In actuality those visual elements which make up the landscape (the lines, shapes, forms, etc.) do not actually exist in the landscape; they are isolated by your consciousness with the help of your vision, and this is what a painter or a sculptor does when he creates not the image of the landscape but the image of his experience of it.

You can find the understanding of the meaning of such a work of art in the same way as when you ask yourself what is the meaning of a tree, of the grass, of the water in the pond which you look at and admire or dislike. The source of it is in your consciousness. We know of no other source of experiences—whether of events outside ourselves or within us—except our consciousness of them. Neither do we have any other frame of reference for evaluating anything we see except consciousness itself. It is there that we have to look for understanding of any work of art.

Feeling alone, or senses or reason alone, cannot bring that understanding or make a choice in a work of art. Feeling may lead us astray. The senses may deceive. Reason may err. But consciousness, as the sum total of all these faculties acting together, is our final frame of reference.

Of Divers Arts
V

I refer you to my previous talks where I tried to explain the meaning of the lines, shapes, forms, and colors in our vision, and it may dispel the assumption that a constructive artist is using an incomprehensible language.

And to disabuse you of another notion you may have gotten, that the kind of art I am doing and the way I do it have no links with art as it was made throughout the past ages, and therefore must have sprung rootless from nowhere, it is necessary for me to acquaint you with the facts about the sources of my art; to show you that my name is not Adam, that my art has a long history, that it not only reaches far back into the depths of human visual consciousness but can be traced through all the traditions of the history of art up to those of my predecessors who lived and worked immediately before me.

I was born and brought up in Russia; my consciousness was molded there. With Russia's language it absorbed her poetry, her myths, and her history. I was fortunate enough to get an education which enlarged that consciousness beyond the frontiers of the Russian culture and helped me to absorb the influences of other cultures as well and to understand that they are all one.

However, in order to know an artist's full mentality, it is instructive to know also the mental atmosphere and the spiritual climate that operated in the formation of his individual consciousness. I will therefore try to sketch for

you the concepts of Russian art and the influence they had on my artistic development as well as on that of my contemporaries in my native country.

Russian art today is at a standstill. It is no longer a free expression of the true experiences of the artist's consciousness. It is supervised by the strict dogma of a ruling party, and the artist is not allowed to develop his creative consciousness freely; all attempts to search for new forms of pictorial expression or any experiments in that field are suppressed under the threat of being declared heresies.

However, in the history of Russian art such a situation is not entirely new. Russian art experienced similar phases in the earlier course of its development. The visual consciousness of the Russian people nevertheless succeeded in preserving and developing its own pictorial conceptions and its own aesthetic values in the arts.

To understand the character of these conceptions one has to approach them with their own standards. The visual consciousness of the Russian people developed under diverse influences. Situated between East and West, Russian culture was undeniably affected by the impact of both. But that did not prevent Russian art from emerging with specific characteristics and establishing traditions according to the phases of its own specific culture.

There is no art in the world without distinct traces of some influences from neighboring cultures. The whole edifice created by human consciousness is nothing else but

Of Divers Arts
V

the sum of interwoven influences, although each separate culture of each country has preserved distinguishable characteristics of its own.

In this respect the development of Russian art does not differ greatly from the development of the arts in the rest of the world. But, for a better understanding of its specific characteristics, we have to study the essence of the visual conceptions which it developed in plastic and pictorial art.

The history of Russian folk art does not go very deep; there are very few relics of antiquity left in Russia: owing to the climate and the prevailing wooded nature of the country's geography, the material available for the plastic arts and utensils was wood, and almost all of it perished. Whatever is preserved does not go back much before the Christian era, but it shows continuous unchanging traditions which persist all the way through to our day.

The imagery in that art contains very little of those symbolic aspects which we find in the ancient cultures. Russian mythology is limited to a very few subjects, all concerned with the domestic life of the people, and this imagery played a secondary part in the visual consciousness of the Russian artists.

The fundamental elements of visual expression—lines, shapes, colors, and forms—are revealed as the focal theme and the main point of interest to the artist in his pictorial language, and in that respect it can be characterized as what is now called abstract.

Of Divers Arts
V

All we know of secular art in early Russian history is concerned essentially with its folk art. It is in the objects of daily use, in the utensils and requisites of domestic life, that the artist applied and expressed his visual experiences of life; there alone do we find the main characteristics of his indigenous art. There the high sense of the vital force of shapes, lines, and colors, of their relation to each other, their proportions in the configuration as a whole—there the concepts of the artist's visual consciousness come to the fore [42–46].

42 Lion with a horse's head. *Carved wooden window sill, Upper Volga region, Russia,*
XIXth century (traditional)

43 Wooden ladle, with handle carved as ducks. *Vologodskaya Province,*
XVIII*th century (traditional)*

44 Large sleigh, for driving out. *Wood carved and painted in polychrome, with iron runners,*
Central Russia, xixth *century* (*traditional*)

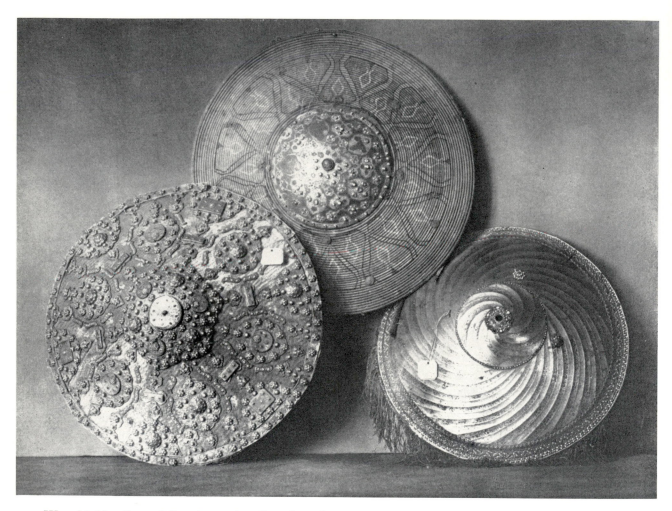

45 War shields. *Central Russia, steel and reed, perhaps* XVI–XVII*th century or earlier*

46 Silver dipper. *Central Russia, once the property of the boyar Theodore Nikitich Romanov (1553?–1633)*

In Russian history we do not know any other kind of secular art such as paintings or sculptures, independent of the art of objects, until the Christian era. It is after the introduction of the Christian religion that Russian pictorial art takes on the form that art had in the cultures of the West.

It is generally known that from the very beginning of its Christian era Russian ecclesiastical art was dominated by religious and aesthetic concepts transplanted into the Russian culture from the Byzantine Empire. For a few centuries the Byzantine Church established itself as the earthly representative of the Divine Universe and kept all the spiritual activities of the nation, especially in the realm of the arts, to strict accordance with its canons.

At the start, Christian iconography was directly introduced from Constantinople. Icons were bought in Constantinople and imported, and Greek architects and painters were sent for to build the churches and paint the frescoes. But the essential and inherent aesthetic spirit of the Russian artists nevertheless succeeded in asserting itself in this new tradition and was freely manifested in the subsequent stages of its historical development, which began in the thirteenth and fourteenth centuries. From then on, Russian ecclesiastical art took a course quite different from that of Western European art.

The rapid changes of style which occurred in Western European art from the beginning of the Christian era did

not affect Russian culture. Russia missed the Gothic; it missed the Renaissance; it was only slightly touched by the European Baroque and that very late; except for the brief pseudo-classical fashion brought in by Peter the Great, not one of the periods which were so decisive for European art left any incisive trace on Russian art. Once established, it remained true to one tradition, and whatever direction it took, it preserved the distinct aesthetic concepts inherent in its visual consciousness.

As in folk art, so in the period of ecclesiastical art, these concepts were:

firstly, idealistic in their spiritual function;

secondly, utilitarian in their social function;

thirdly, abstract in their formal content.

Faith was the leading and binding spirit in it. The highly mystical idealism of that faith considered the material aspects of the external world as something very remote, very crude and imperfect in relation to the spiritual image of the Divine Universe.

The rigid frame of canonical rules which the Byzantine Church at first imposed on Russian art very soon began to loosen. In the thirteenth century, by the time Byzantium itself lost its power, the economic and cultural ties were broken. In the fourteenth century, Russian ecclesiastical art freed itself from the Byzantine schemata imposed on it. Although a certain traditional pattern remained for the artist as a guide in his compositions, this was due more to

Of Divers Arts
V

the method of working and to the organization of the artistic teams working all over Russia in different centers. Only a few individual names of outstanding artists are known: Theodosius, Dionysius, Theophanes the Greek, Rublev, and a few more, each of whom left distinct schools. But there were many other Russian painters in the period between the thirteenth and seventeenth centuries who remained anonymous, merged in the collective bodies of artistic schools whose influence on Russian art was vital [47–57].

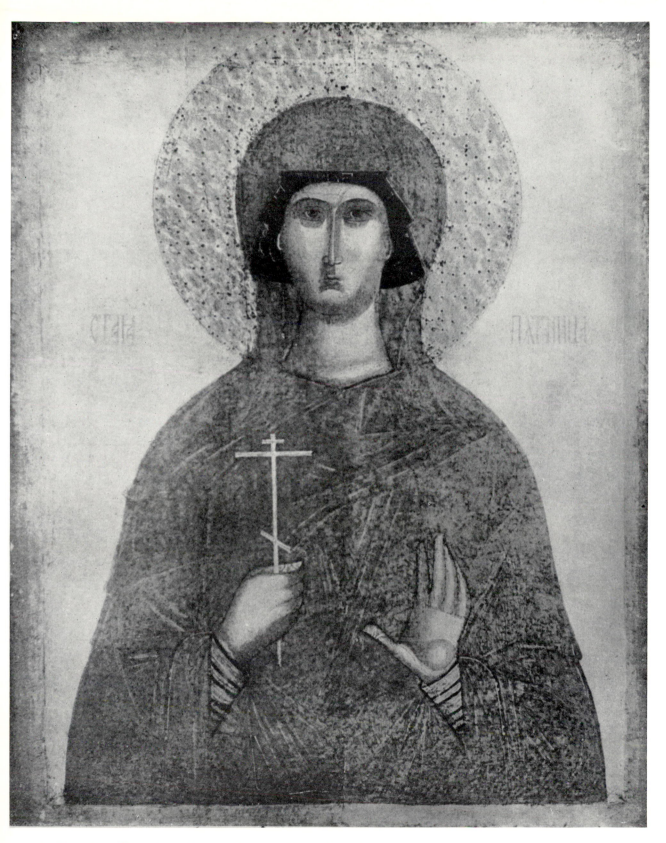

47 St. Paraskeva Pyatnitza. *Fresco, Novgorod School,* XIV*th century.*
Church of the Rogozhinski Cemetery, Moscow

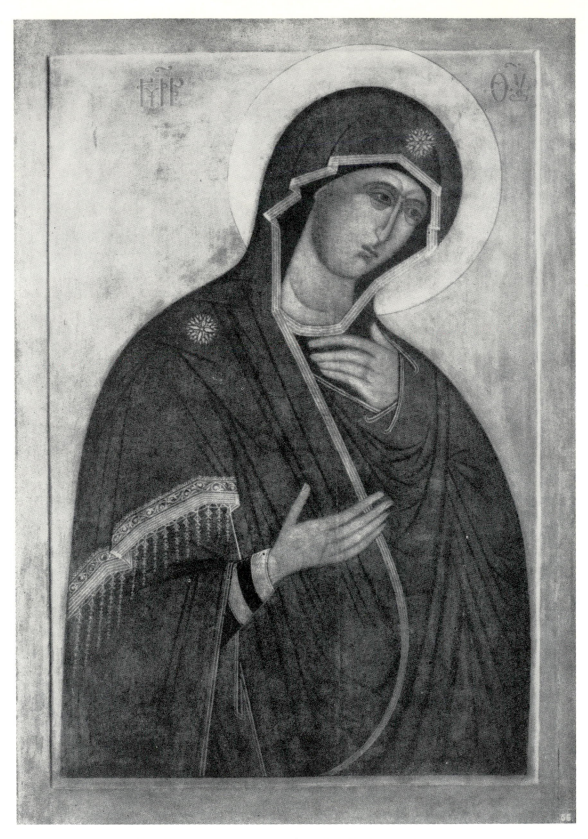

48 The Mother of God. *Painted icon, school of Andrei Rublev, xvth century*

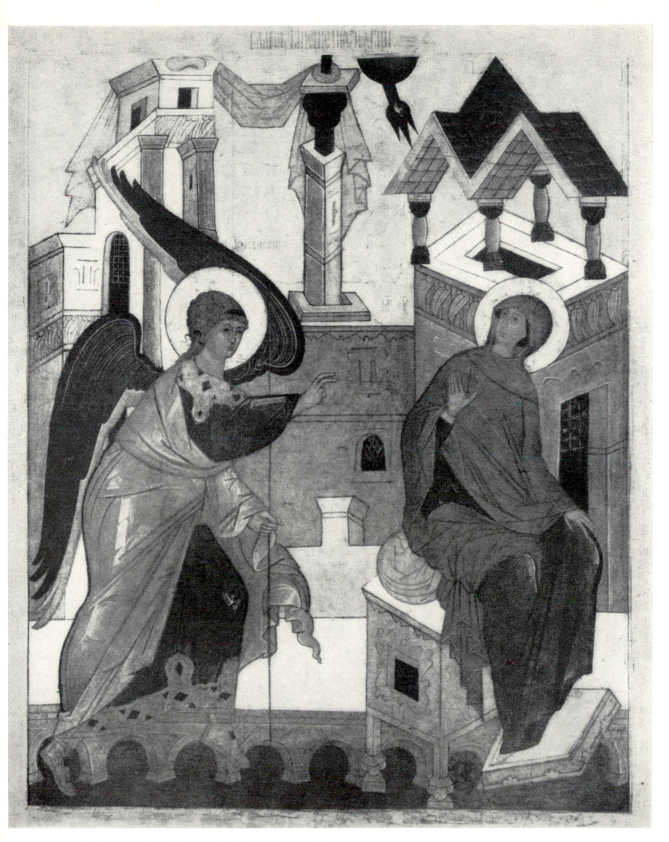

49 Annunciation. *Painted icon, school of Pskov, xvth century*

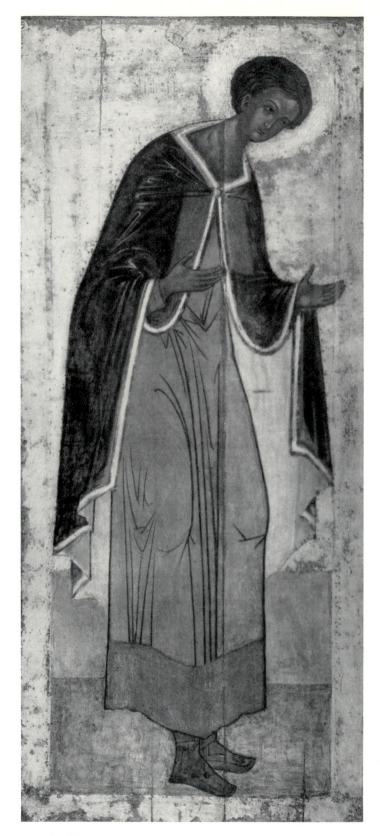

50 St. Demetrius of Salonika. *Painted icon,*
Troyski Cathedral, Moscow

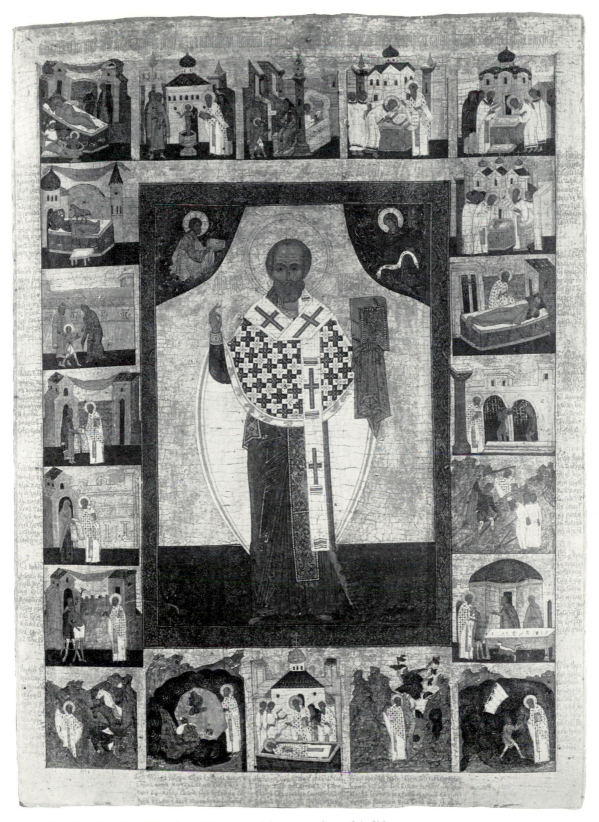

51 St. Nicholas the Wonder Worker, with scenes from his life.
Painted icon, school of Novgorod, XVth century

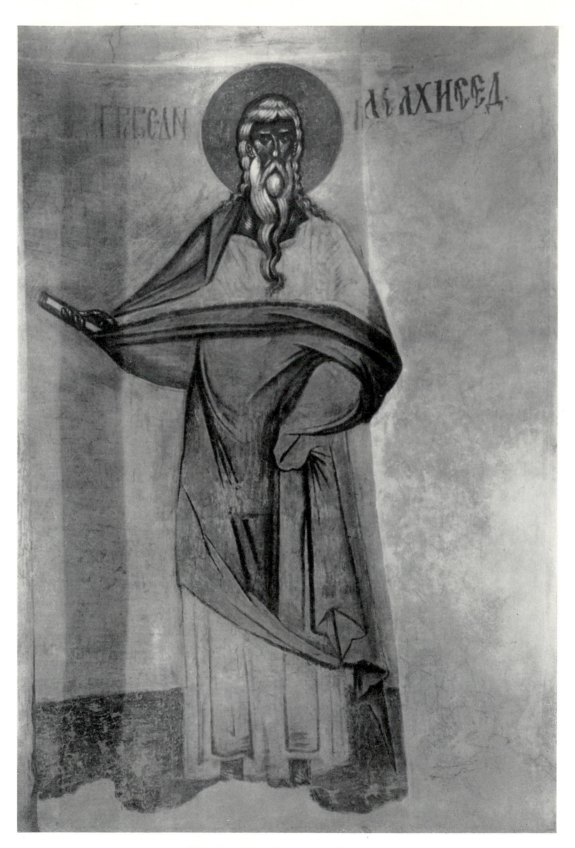

52 THEOPHANES THE GREEK: Melchizedek. *Fresco, 1378,*
Church of Our Saviour on Ilyínka, Novgorod

53 *Detail of 52*

54 THEOPHANES THE GREEK: Standing Virgin. *Detail of a fresco*, XVIth *century,
Annunciation Cathedral, Moscow*

55　THEOPHANES THE GREEK: *A Stylite. Detail of a fresco, 1378,*
Church of Our Saviour on Ilyínka, Novgorod

56 St. Clement. *Detail of a fresco, c. 1375, Church of Volotovo*

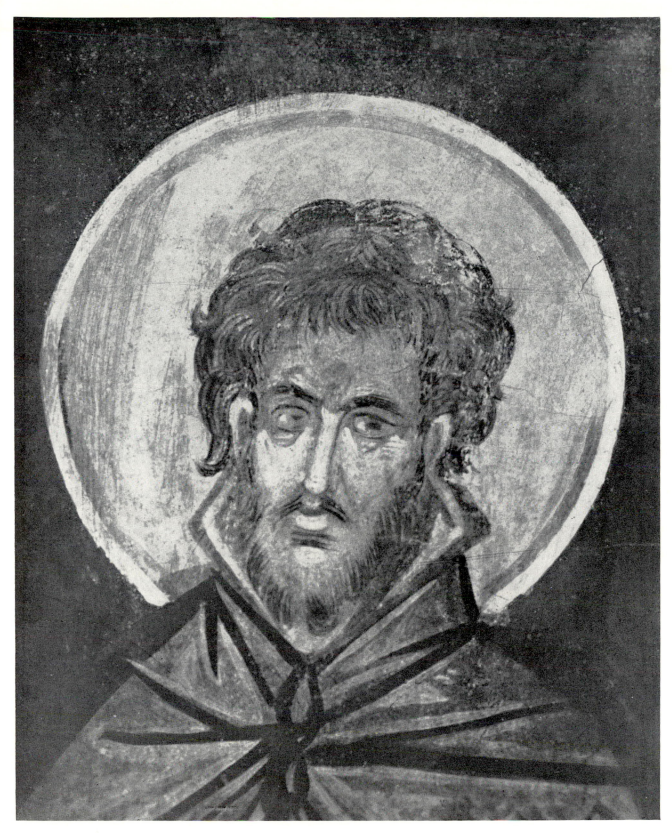

57 A Martyr. *Detail of a wall painting, 1380, Church of Kovalevsky*

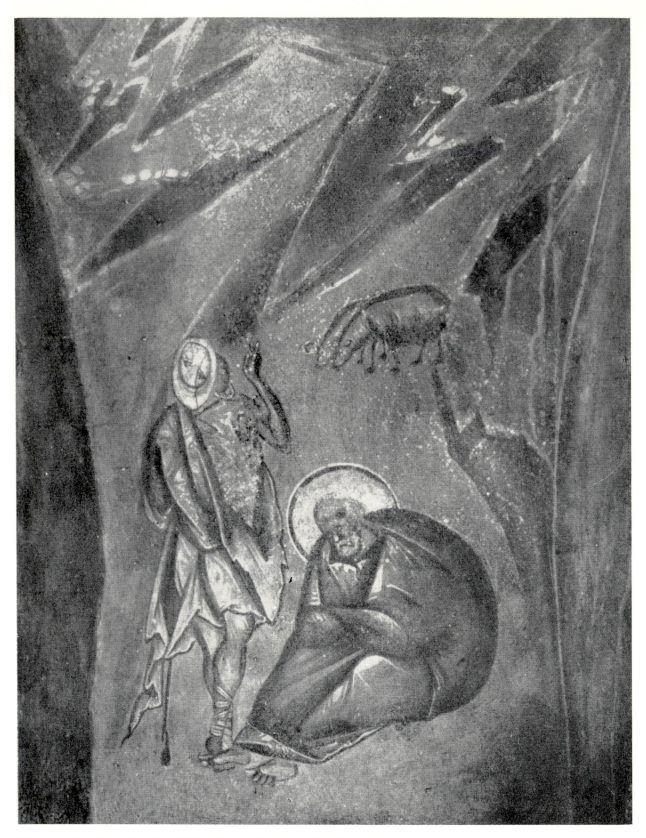

58 Joseph with a shepherd. *Detail of a fresco of the Nativity,*
1363, Church of the Assumption of the Virgin, Novgorod

The manner of working was thus: each outstanding artist left a set of patterns which the Church canonized, but these patterns were only tracings of the silhouettes of the figures and their places in a fresco or an icon; all the other elements in a composition were left free for the individual imagination and artistic ability of the team of masters who executed it. In addition, the silhouettes themselves were not immutable.

It was natural, therefore, that for the Russian artist an ecclesiastical painting constituted only a loosely outlined scheme within which he could exercise his individual talent with full freedom, and there he preserved and carried out his inherent aesthetic conceptions.

He willingly accepted the limits put upon him by the rules of the Church, considering the pictorial fields left to him to work on sufficiently broad and rich for his individual pictorial expression.

The basic idealism of his faith was identical with the faith of the Church; and as, according to the essence of that faith, his art had to be, as far as possible, detached from the crude realism of the material world, he did not need to look for inspiration to imitation of the material aspects of Nature. He found the source for his compositions in the inner world of his aesthetic impulses, and there, as in his own folk art, every line in his icon or fresco, every shape and color, was transformed from a detail into a theme. In fact, with these elements alone the Russian

artists displayed the original variety of pictorial expression which makes Russian ecclesiastical art so rich and impressive.

I have dealt up till now with only one concept of Russian art, which is in form "abstract." But there was another very important side to the Russian attitude toward visual art; that is, to the Russian consciousness a work of art was first and foremost a social phenomenon. It was valid for its social utility, spiritual as well as material; spiritual, in that it had to perform the function of a link between man and the Divine Universe, and thus to be accessible to all and not only to a privileged few.

An icon was, for the artist as for everyone else, a ritual object, a thing to be worshiped and to that extent a utilitarian requisite. It had to function not only in the Church and in the private home but to be carried about from house to house, from village to village, from town to town; to be carried by every unit, whether a team of craftsmen or warriors on the battlefield, as the guardian of their life and vocation.

A work of Art, therefore, was not meant to appeal only to a limited group of educated individuals. It is precisely *Of Divers Arts* because of these concepts (i.e., abstract and utilitarian), *V* which were implicit in Russian secular and ecclesiastical art as a common characteristic of the Russian visual consciousness, that the link between the artist and the common man was the closest.

By the end of the seventeenth and during the eighteenth century, Russian ecclesiastical art reached its decline, and the whole economic and social structure of Russia was altered by the impact of new influences from the West, brought in by Peter the Great. Russian art took a new direction. Western European naturalistic concepts took hold, and portraiture and descriptive painting developed. Sculpture, which had previously been rather discouraged by the Russian Church and was confined to the shaping of utensils, appeared within the field of interest of the Russian artist.

For two hundred years this new aspect in Russian art prevailed, but owing to its exclusive character it was extraneous to the inherent conceptions of the Russian artist, and it did not produce any results in Russia essentially different from what was being done in Western European art.

Art lost its ties with the common man, and in his view it was confined to the world of the ruling class, foreign to him. But even two centuries could not eradicate the innate aesthetic conceptions of the Russian people.

No wonder that toward the end of the nineteenth century we see a rebirth of those fundamental, idealistic, and abstract concepts which always prevailed in the whole previous history of Russian art. They reappeared in a different form.

They begin to be seen again in part with a group of

artists who called themselves "Wayfarers." Their avowed aim was, in the first place, total submission to the so-called naturalistic aspects of the world. In that respect they still accepted the Western European ideology characteristic of European art at that time.

Their work was in no way different from or better than what was done in Western European art—I would say rather, poorer. However, they infused something of their own into it: they demanded from the artist that his subject should carry an event close to the life of the common man. This was true not only of the artist, the painter, and the sculptor, but also of the writer, the poet. It was in accord with the prevailing populist idea in all branches of intellectual life in Russia at that time.

The idea of the Wayfarers was to bring Art to the people; to carry their exhibitions to the remotest corners of the country—and they did so. (You may hear the echo of the old concepts of Russian art in that ideology!)

This kind of ideology indeed flows broad and shallow in the Russian art of today. You can see examples of it in every exhibition of Russian art which the State sponsors.

Of Divers Arts
V

But at the same time as the Wayfarers were active, another trend was revived in Russian art whose roots struck far deeper in Russian culture and which was more germane to its inherent concepts in visual art.

The leading spirit of that trend we find in Mikhail Vrubel. It is matter for regret that the art historians of

Western Europe are almost entirely unaware of the work of this artist, of its profound significance in the formation of the new concepts in Art which now prevail all over the world, and of his primary influence on the subsequent generations of Russian artists and on my contemporaries, including myself. I will therefore try to give you a broad idea of the life and work of this artist.

Mikhail Vrubel was born in the town of Omsk, in central Siberia, on March 5, 1856. His father, Alexander, was a Pole, an officer in the Russian army. His mother, Anna, née Basargin, died when he was three years old.

He was brought up at home by his stepmother, who was a musician—a pianist. He grew up in highly cultured surroundings amongst books, engravings and drawings. His sister Anna, in a memoir of her brother, says that young Mikhail would stay for hours listening to music and that in the family he was called "the silent philosopher."[9]

The need to draw had developed in him by the time he was five. He would draw with great speed, from memory, the scenes of his home surroundings; and his father, noticing the boy's obvious talent, did all he could to help him develop it.

When he was eight the family moved to St. Petersburg, and his father placed him temporarily in an art school. But when the family afterwards moved to Saratov, Mikhail was entered at the *gymnasium* there.

His sister tells that when the Catholic church of the

small town of Saratov exhibited a copy of Michelangelo's fresco *The Last Judgment*, Mikhail insisted on seeing it again and again, and then one day he reproduced a copy from memory which was astonishing in its preservation of details.

His studies at the *gymnasium* kept the boy from painting, and not much is known about him during those years. When he was sixteen, in a letter to his sister, he mentions that he is painting a portrait in oils of their deceased brother and promises that he will paint next the other members of the family. He was graduated from the *gymnasium* in 1874 and continued his education at the University of St. Petersburg from 1874 to 1879. In the summer of 1876 he traveled through Germany, Switzerland, and France as tutor to the son of a wealthy merchant.

During his time at the University he made a great many drawings, most of them illustrations to the books he was reading. During the short time he was in Paris and Switzerland his correspondence was filled with drawings, but unfortunately all these are lost.

After graduating from the University in 1879, he was at first inclined to a career in law, but he very soon discovered that he could not live without Art, and he entered the Academy of Arts at St. Petersburg in 1880 and graduated in 1884.

One characteristic sign of his mental state while at the Academy can be found in one of his letters, where he says

Of Divers Arts
V

that his point of view diverges from what the Academy demands; he finds "the schematization of living nature revolting" to his feelings, and during his last year at the Academy he was already trying to free himself from it and work on his own.[10]

There are many works of that period, mostly, of course, in the classic style; nevertheless there is, even in that style, an extraordinary dexterity and, I would say, virtuosity, which his professors could not fail to see.

What is preserved of the testimonies of his comrades in the Academy shows that they unanimously admired him as the only outstanding one amongst them—admiring his enormous love for Art, his enormous capacity for work, his almost fanatic devotion to painting, and his extraordinary original talent.

And yet, as so often happens in the history of Art, when this artist was at the height of his unfolding genius, the same artistic milieu fixed the label "decadent" on him.

At the end of his period at the Academy, he got a job in the Cathedral of Vladimir in Kiev. It is there that his study of the conceptions of ancient Russian art and its profound vision of the true values in painting began. It is at that time, when he was preoccupied with the frescoes for the Cathedral, that his genius unfolded.

That period was not at all a happy one. To begin with, he had to do much more work restoring the old frescoes than painting on his own. Furthermore, owing to the

development of his own new technique and new vision over a period of several years, the Church authorities found him too radical, and when it came to painting the new frescoes for the Cathedral of St. Cyril in Kiev, his sketches were refused. Vrubel, who was living in great poverty at that time, was forced to work as an executant of the sketches accepted from one of the most mediocre artists of the time. He accepted the job because of his abject poverty. How abject it was, we know from the testimony of his father and of others.

We know that he was living and teaching for a while in the schools of Odessa and in Kiev, and then went to Moscow, where he stayed. We know that all these years he lived in great material need, lonely, unrecognized, and even derided as the "Jupiter of the Decadents."

Were it not for a few patrons who saw in him not so much a revolutionary as a continuator of the old tradition of Russian iconography, and were it not for the enormous enthusiasm which he knew the young generation had for his work, it would have been no wonder if the fatal illness which attacked him in 1902 had struck much sooner. From the year 1902 to his death in 1910, he was a patient, off and on, in a psychiatric clinic in St. Petersburg. Though in his lucid intervals he continued to draw and paint, all that he created at that time were memories and visions of his previous images.

I would like to quote here some extracts from an article

written by Vrubel on June 24, 1902, as an obituary on the death of an artist friend, Rizzoni, who committed suicide in the midst of his artistic career.[11] It may shed some light on Vrubel's character and his position amongst his contemporaries.

"I was very deeply shaken and affected by the end of A. A. Rizzoni. I cried. What could have driven such an honest and sincere master, such a strong character, into the abyss of despair? You may say I am partial to a friend. Quite recently in the pages of the journal *Mir Iskusstva*, they have so contemptuously and so partially treated his honesty. Gentlemen, do you forget who is judging us artists? Who has not taken liberties with us, whose crude hands have not banged on the fine strings of an artist's creation? At the risk of being paradoxical, I have only to mention the name of Ruskin.

"How much interest to the artist is there in this enchanting chatter?

"I am not talking about the unwashed hands. Has not this bacchanalia fatally succeeded in obscuring the understanding of our mentality?

"Yes, we have to have a good look and to revaluate a great many things. But it is necessary to keep in mind that the activity of a modest master is incomparably more genuine and more useful than the pretensions of voluntary and involuntary neuropaths who lick the plates at the feast of Art. The most disgusting of them are the voluntary

153

ones. In my memory I know many names which I would rather not mention. And then this undignified agility and ridiculous aping which so disgusts the honest spectator that for years now I have not visited an exhibition.

"As a counterpart, I would have liked to sketch a silhouette of the serene image of the deceased. I knew him intimately. I was too young and too different from him in tastes and methods of work to be able to flatter him, and in spite of that there are very few from whom I have heard such just, objective, and sympathetic appreciation of my work. And it was just at that time that I was branded as the 'Jupiter of the Decadents,' by those who in their naïveté thought that that was a terrible evil."

And then, after giving a short sketch of the career of Rizzoni, he concludes his obituary with these words: "It is time to see that sincere work is the value of the man no matter what his aims are. It is there that he will assert himself. With this truth man has crawled out of his cave in history. Dear Stone-Age Man! What great reproach and challenge your honesty throws in the face of the impostors!

"Let these lines be a wreath for him who died insulted."

Of Divers Arts
V

These words, indeed, might serve as an obituary for Vrubel's own career. Very soon after writing that obituary, Vrubel himself was struck by the fatal illness which after almost ten years (with short intervals) brought him to his grave in 1910.

The impact of Cézanne on the subsequent development of the visual arts in Western Europe is well known to every student of art today as well as to the general public. But it is also important to know what was the impact of the work of Vrubel on my contemporaries in Russia, including myself. His genius is responsible for molding the visual consciousness of our generation, which came after him, and it was decisive for all of us—those who stayed in Russia as well as those who afterwards joined the general stream of modern art in Western Europe.

The new formal conceptions which many of us later on introduced were a logical consequence of Vrubel's technical and formal innovations in painting and sculpture.

We were all, at one period or another of our development, products of his genius. His new vision brought us to understand the sources of the ancient Russian pictorial concepts and made it clear that these concepts are not just a national art of Russia which died with the passing of iconography, but have a vitality and function in the consciousness of men's vision through all ages and artistic styles.

Vrubel freed the arts of painting and sculpture from the academic schemata. He revived the concept in visual art that the fundamental visual elements are of decisive importance in the creation of a pictorial or plastic image; and, in that respect, his influence on our visual consciousness was as decisive as Cézanne's, and equivalent to the latter's on the trend of painting in Western Europe.

And when, at the beginning of this century, many of us came in contact with Western European art, we did not come to a foreign land; we came back home, and Cézanne was accepted by us quite naturally.

It was not an accident that the Russian collectors were the first to understand and accept the new trend in Western art which was inspired by Cézanne. They were the same patrons who also collected the ancient Russian icons and belonged to the circle of those who, in Vrubel's time, kept him alive.

I would like now to show you a few examples from which you may see the truth of my statements [59–66].

Of Divers Arts
V

It is not the subjects of Vrubel's work which impressed my generation of artists but his new pictorial vision and the technique he introduced.

Even Cubism was not entirely a surprise to us.

Detail of 59

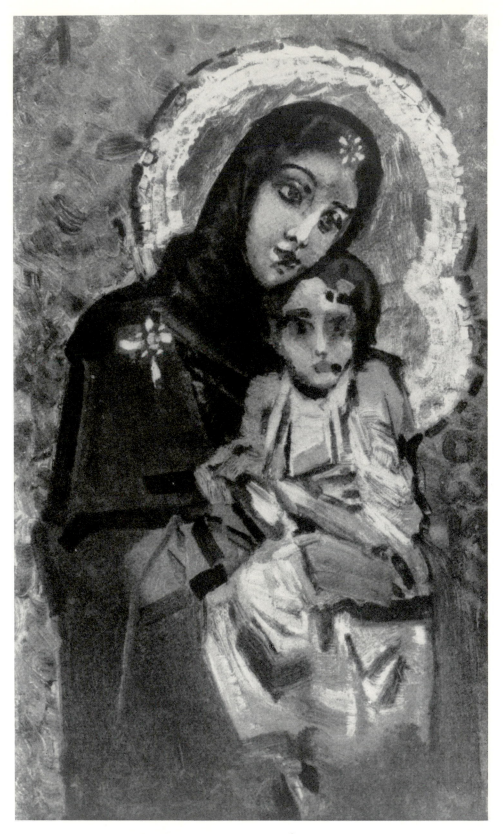

59 MIKHAIL VRUBEL: Madonna and Child. *c. 1890*

Detail of 60

Detail of 61

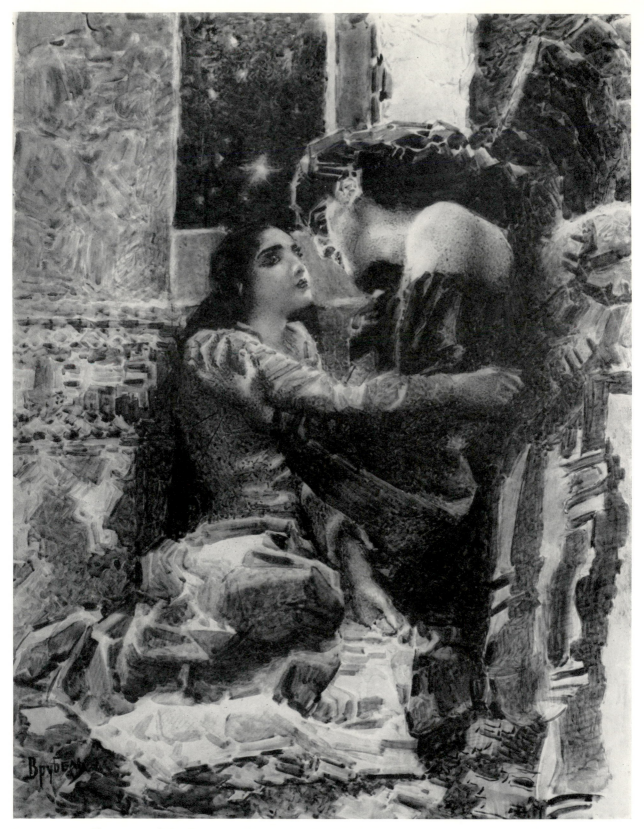

60 VRUBEL: Tamara and the Demon. *Illustration for M. G. Lermontov's poem "Demon,"*
1890–91, black and white watercolor on brown paper

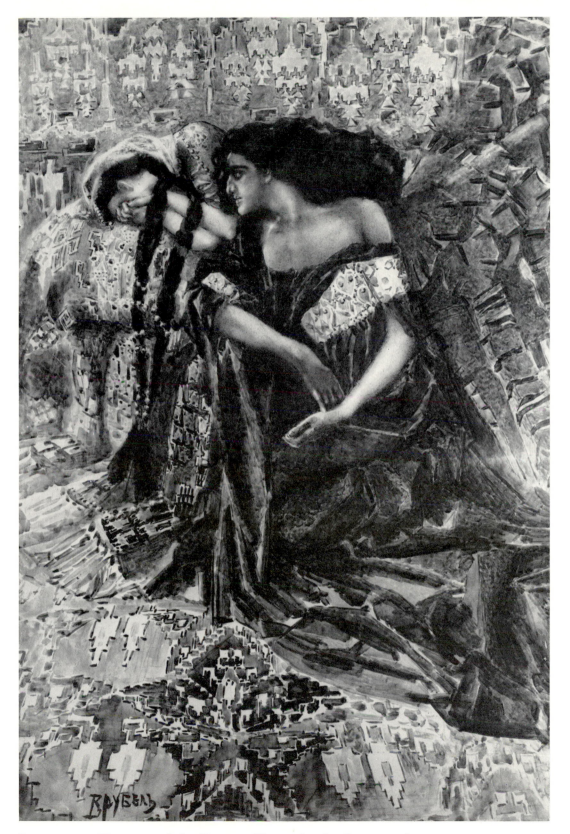

61 VRUBEL: Tamara and the Demon. *Illustration for Lermontov's poem*
 ("Do not cry, my child, do not lament in vain! . . ."),
 1890–91, black and white watercolor on brown paper

62 VRUBEL: The Rider. *Illustration for Lermontov's poem "Demon," 1890–91,*
 black and white watercolor on brown paper

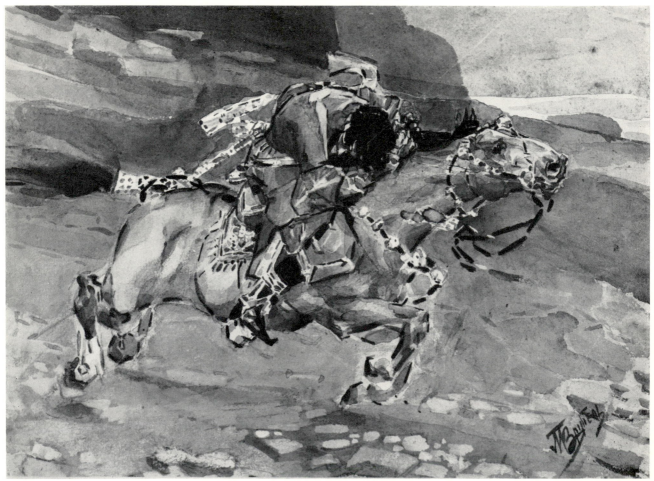

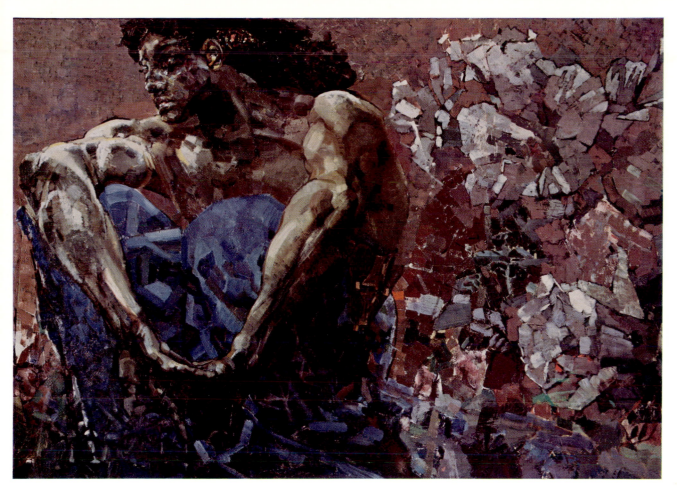

63 VRUBEL: Seated Demon. *Illustration for Lermontov's poem, 1890–91, oil.*
Note technique of right half

64 VRUBEL: Design for a stage setting for *The Merrie Wives of Windsor*, never executed.
1892–93, watercolor. Note technique of chair, table, and flowers nearby

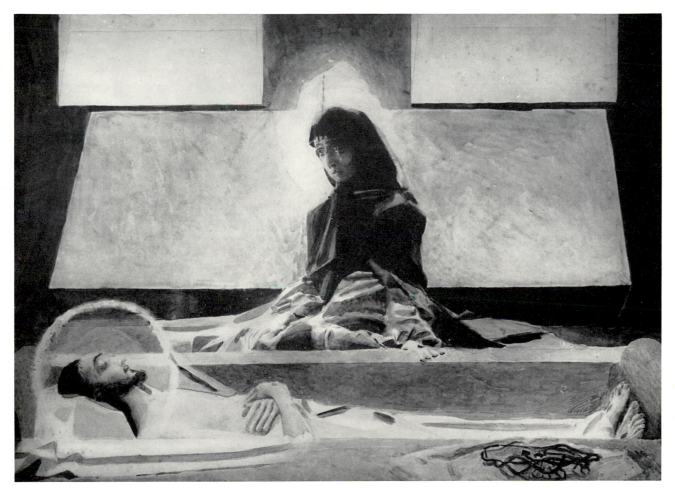

65 VRUBEL: Pietà. *1887, painted for the Vladimir Cathedral, Kiev*

66 VRUBEL: Two figures. *Sculpture, 1896*

When you look at these details from a painting made by Vrubel in 1890 [68] and compare with a Cézanne painting of 1905 [67], you may clearly see for yourselves that our conscious vision in painting, acquired by studying the technique of Vrubel, had prepared us for an acceptance of the experiments of the Cubists in which we could then join on equal terms with them [59–63; 69–70].

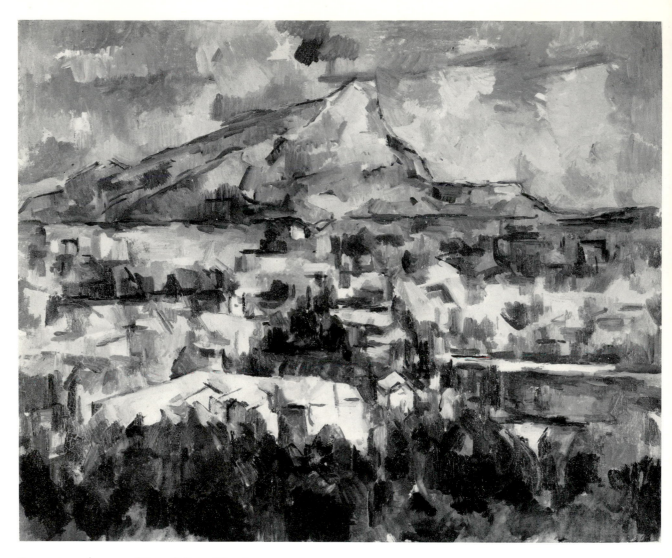

67　PAUL CÉZANNE: Mont Sainte-Victoire. *c. 1905*

Detail of 67

68 VRUBEL: Demon Looking at a Dale. *Illustration for Lermontov's poem "Demon," 1890–91,*
black and white watercolor on brown paper

Detail of 68

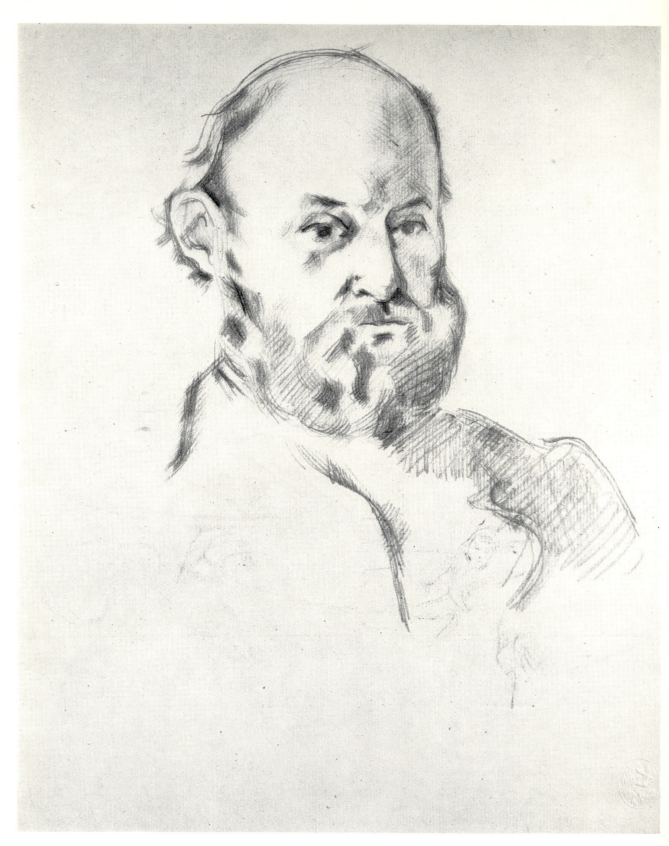

69 CÉZANNE: Self-portrait. *Drawing*

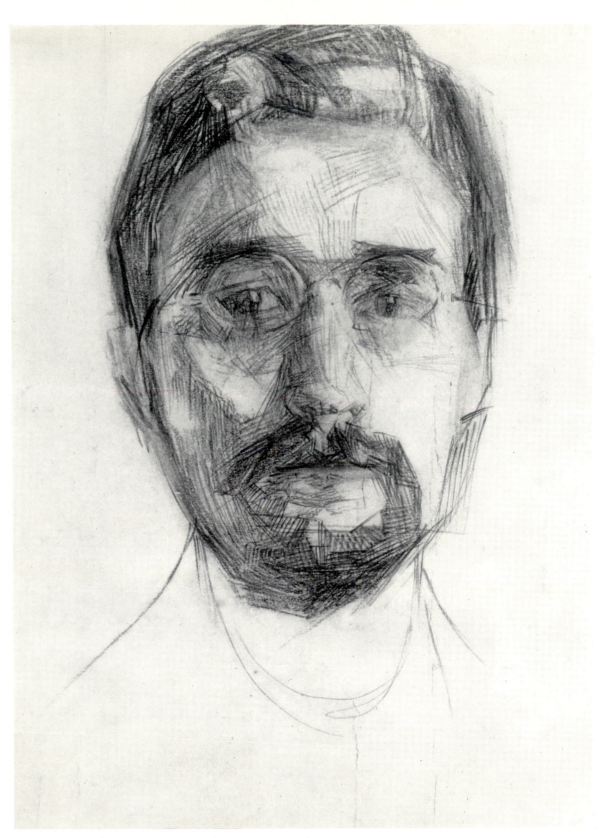

70 VRUBEL: Portrait of Doctor Levitsky. *Drawing*

Of Divers Arts
V

The nonobjective ideology proclaimed by the Suprematists in 1915 is the consequence of the rejection of Cubist experiments, but an art historian will not fail to see the real and complete influence that the concepts of Russian art—of the icons as well as of Vrubel—had on the mentality and conscious vision of that group of artists in Russia [71–72; cf. 61].

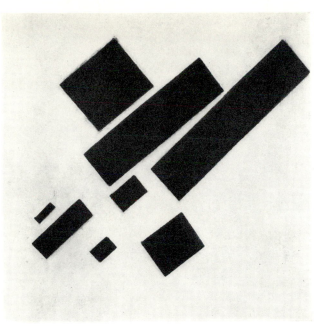

71 KASIMIR MALEVITCH:
 Eight Red Rectangles. *c. 1914*

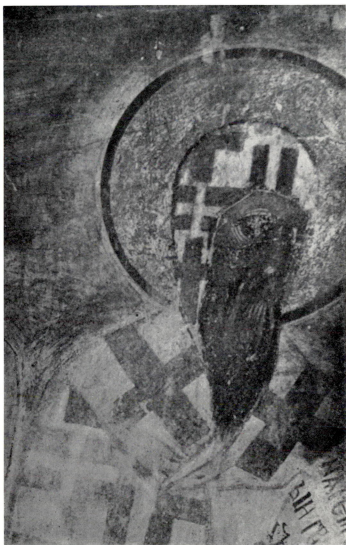

72 A Church Father. *Detail of fresco,*
 1363, formerly Church of the As-
 sumption of the Virgin, Novgorod

It is for future historians to study the work of those artists and to learn how much the interchange of ideas among artists of different countries contributed to the resurgence of what today we call the contemporary visual consciousness. But it would be a grave mistake to attempt to ascribe the merit of initiative to any one of them. I firmly believe and am convinced of only one thing—that ideas have no boundaries, and their roots reach far back into the past, into all that has been done and thought by the collective human consciousness. No wonder that these roots sprouted independently in different countries, producing similar flowers.

Whether these ideas are scientific, pictorial, or poetic, they are the products of a state of human consciousness which is simply human, not Russian, French, Anglo-Saxon, and so on, and any attempt by any one intellect to appropriate an idea for his own country or for one single individual is one of the greatest blunders and the most blatant falsifications, injurious both to the idea itself and to the human consciousness which is the creator of it.

VI

WHENEVER YOU HEAR from anyone who tries to construct an image, to formulate an idea, or express an experience through any form of Art, poetic, plastic, pictorial or scientific—if you hear from him that he is doing it only for himself, he is telling you only part of the truth, and very often a plain untruth.

Only in dreams do we dream for ourselves. Only in thought do we think in solitude, and only in imagination do we imagine in secret. But at the moment when our dreams, our thoughts, our imaginations overflow the silent chambers of our consciousness, we enter a state where the urge to communicate them to others becomes irresistible.

We are compelled to form them into some kind of visible, thinkable, palpable image, and in doing so we are no longer doing it exclusively for ourselves, we are transmitting them to others, and the artist himself is merely the first of those others. When our work is done, it no longer belongs to us; it becomes the spiritual property of those who receive it and of the society in which we live.

I have often heard artists complain of the public's neglect of its duty to them, forgetting that nobody owes us anything for the fact that we are breathing the air, that we are thinking our thoughts, that we are forming images of our experiences, and that the only reward we can ask is not to be denied the right to do these things.

But even more often have I heard the public's complaint and demand from the artist that he fulfill his duties to them. Yet no one of the public has shown me any justification for such a demand; it is as wanton as all the rest of man's desires to appropriate rights for himself without having any right to do so.

I have said on several occasions, and will say again now because I firmly believe in the truth of it, that "a work of Art with that alone which the artist puts into it is but a half of itself; it attains its full stature by what time and people make of it."

Of Divers Arts
VI

What I mean by this is that the artist is not alone responsible for what he does in his art, but society shares with him the responsibility for the image he transmits in

176

his work. So when you ask an artist to give you the reason for his art, its aims and purpose, it is necessary for your better understanding of the answer he gives in his work to know what kind of experience he gets from the society he lives in. All his images derive from these experiences, and so you have to know the mental state of that society.

The mental state of our society today in which contemporary artists live and work is in a confusing flux, and as you are a part of it, it concerns you, the public, also.

The artist will tell you that you live in the grip of an anxiety which makes your actions unpredictable and irresponsible.

You cannot face actuality, you cling to your memories, to experiences of the past; having lost the stability of that past, you shrink before the unknown, unexpected specter of events to come.

Having lost your security, you are losing confidence in yourselves, and do not dare to anticipate.

Seeing and living with the shredded heaps of old ideas which you believed in as truths but have now discarded, you have become insensitive to any new idea from wherever it may come and whoever is the bearer of it.

Seeing the old standards of morals and aesthetics broken up and thrown on the muckheap, you have to live without any measures to distinguish the evil from the good; and you do not recognize ugliness for what it is when you see

it, because you could not care less. But you despise him who dares to come to you and moralize.

Harsh as those words of the artist may sound, there is great truth in them. Indeed, in a society in such a mental state, man is becoming much less than a stranger to man, he is only a passer-by.

Every one of us, if he is sincere with himself, knows that we know nothing of that pedestrian whom we pass, and we do not care to make an effort to know anything about him, because we know that, for him, we ourselves are only passers-by. We forget that at the moment when our paths meet our lives become dependent on each other, and that this fact is perhaps the only thing which keeps us from destroying each other, so that we have survived up to now on this planet.

But even this dependence has become so tenuous that it is threatening to vanish altogether, because the paths of our lives are getting more and more separated and the occasions for them to meet even rarer, so that man is already becoming superfluous to his fellow man.

All the signs are already here that our care for man's life is limited by our interest in the functions he performs.

Of Divers Arts
VI

Indeed, what do we care, what interest can we possibly have in the individual who has made the things we see in the shop window?

The musician in an orchestra which we hear over a radio program, the cashier in the subway, the driver of the

railway train, the thousands upon thousands of men who work in the offices in the cities where we live—do we feel their existence, their actuality as human beings?

Only their functions matter to us, and in the end these functions can, indeed, be performed by a machine; it is already being done that way, and we may even not notice how one day we shall all stand there an abandoned multitude of human bipeds, strangers to each other, dependent on the power and under the command of a robot.

It may serve us as a good reminder to quote the words of Benjamin Franklin, who wrote in a letter to Joseph Priestley in 1780:[12] "The rapid progress true science now makes, occasions my regretting sometimes that I was born so soon. It is impossible to imagine the height to which may be carried, in a thousand years, the power of man over matter. We may perhaps learn to deprive large masses of their gravity, and give them absolute levity, for the sake of easy transport. Agriculture may diminish its labor and double its produce; all diseases may be by sure means prevented or cured, not excepting even that of age, and our lives lengthened at pleasure even beyond the antediluvian standard. O that moral science were in a fair way of improvement, that men would cease to be wolves to one another, and that human beings would at length learn what they now improperly call humanity."

Indeed, it took less than a thousand years for the scientific genius of man to reach in our days to a power so

overwhelming and so far-reaching that it promises us the conquest of the whole universe.

Man's technology has developed to such a height of skill that there is no technical task, no problem that it could not solve, no structure that it could not build to make of this earth of ours a fulfillment of man's dream of the "lost Paradise."

Instead, man seems to have made up his mind to abandon this planet altogether. In his mental aberration, man is already preparing to reach out for new adventures in the conquest of new and distant planets, ignoring that he has nothing to take there except his strifes, and failing to conquer and share with his own planet Earth the riches abounding in it. Overwhelmed by the dazzling display of new knowledge which the scientific genius in his midst is offering him, blinded by it and incapable of digesting it, unprepared to understand all the constructive possibilities Science promises him, man uses Science for those ends which in his confused state of mind he can easily and immediately grasp—the ends of destruction.

Of Divers Arts
VI

What use does mankind and its societies make of our Science? What do we take from it to improve ourselves, to assuage the forlornness of our mental state, the lonesome fear of the coming day? The only remedies our society has taken from Science and its achievements are the remedies for healing the sick amongst us today, as individuals, so that they can die en masse tomorrow.

Losing rapidly the binding link between one human being and the next, deprived of the sense of the necessity of his life if we want to sustain our own, cutting the very fibers of our interdependence without which the human race cannot possibly continue to exist, we are building, hastily and wastefully, bigger and better and more monstrous devices of destruction; and as our cities spread like ant heaps in the wilderness, and crowded humanity has to consume its life in a daily stampede, making the conditions of these ant heaps too contaminated and congested for even an ant to live in, we elevate these human beings on to a higher grade of the zoological ladder and build for them ever bigger and taller rabbit warrens, packing as many of them together as tightly as their bodies can stand and still breathe and multiply, so that nobody could call us prodigal.

Think now of the artist who is living in these conditions and who gets his experiences from them. A fleeting survey of the contemporary arts can give us the picture of what the artist today thinks and feels and what his attitude is to all that he finds in our society.

The crowd of artists of today can be counted in tens of thousands, but they can nevertheless be divided into distinct groups, according to what aspects of the mental state of society their work reflects and according to their response to their experience of these aspects.

We can easily discern them in the visible images they

are making and communicating in their painting and sculpture.

In the first group I would place the bulk of them. They are the majority. Like the other majority of the multitude of humans amongst whom they live and upon whose shoulders the whole structure of our society rests, these artists go on with the daily tasks of their art with patience, with submission, and in spite of all adverse conditions and perturbations which they know are disturbing the minds of their society.

Their own minds, however, remain unperturbed; they continue to paint what they see, and they paint for their bread. Holding on to the glorious past of Art, which was good for their ancestors, they are convinced that it is good enough for them; they let others worry about the search for new avenues in Art.

But there is another group of artists today of a quite different caliber. They do not cling to the glorious past of classic Art, because their consciousness conveys to them experiences which their ancestors did not and could not have, since they lived in a different age with different conceptions of the world and in an entirely different social and mental structure.

Of Divers Arts
VI

These artists are fully aware of the fact that the civilization in which classic Art was born and bred is breaking up before their eyes, and they see the glaring signs of something new coming—new conceptions of the world, strange

and powerful images of unexpected aspects, new technologies, new structures of social order.

True, for the present, the picture of change which they are witnessing they see only in a haze of uncertainty; yet its contours are clear enough to be recognized by them for what they predict, and what these contours predict they do not accept and do not like.

Their natural first impulse is to escape, and the nearest place of escape, as we know from our own experience, is into ourselves. That is what they do in their art. From there on the artists of this group divide and go in different directions.

Some of them find solace in those rudimentary chambers of their own consciousness which lead them back to their primeval existence. They look for comfort to the images which primitive man created to express his experiences. These artists find in those images a similarity to their own primordial memories. And as we see nowadays in many examples of contemporary art, they reproduce them in their sculptures and paintings; their works remind us of the sculptures and paintings we see in ethnological museums.

These artists are not faking their experiences. They are true and sincere experiences of their own consciousness. They are experiences of the historical man in them, awakened by their own fear of what is coming—by their own anxiety about what is going on in the confusion of our

time. They submit to the oppressive power of this anxiety, and there, in that depth of the ancient conceptions of man, when his consciousness was full of fear and the world was populated and governed by implacable forces, they find an echo of the state in which they themselves are, and they submit to it.

Other artists of this second group take flight into those states of their consciousness in which it is not acting with all its faculties, but with only a few of them and not with its full controlling force, namely, into the world of their night dreams. And when we study the images of these dreams, we can easily discern the disproportionate dimension that the depressive actuality of their experiences in the waking state has imprinted on their consciousness. You will not find a trace of joy in these images, not a glimpse of hope; fear, melancholy, and despair are the main traits in the images of this group.

Neither of the two kinds of artists of the group I am now talking about is the product of our immediate contemporaneity. The conception of that art was reborn in the second decade of this century, but we can find it also in critical phases of long past history.

Of Divers Arts
VI

But there is one section of artists in this group whose attitude toward art is different from both of those I have mentioned. They appeared only recently, but are at present in full swing, and their art can be defined as the art of

rebellion. It reflects in more forceful terms the mental state of the society they live in today.

The artists of this group do not look for escape; they are not so easily frightened by what they see, nor are they frightened by their memories, since they have no experiences of the past and no memories of it. They were born and brought up in the midst of the devastating wars and revolutions of this century and in the midst of a dissolving civilization. Their consciousness has not had time to absorb those healthy remains which always survive in every dying civilization to carry the stream of human culture ahead into a new one.

But the urge for visual expression with which, as artists, they are born is still strong enough not to be abandoned, and the only experience they have is the experience of utter dissolution. They find themselves deprived of any faculty to remedy the mental chaos surrounding them. They find themselves victimized by the process of disintegration in their society, and they hoist the flag of rebellion. Like any child who is frustrated in his desires, they go into a fit of tantrums and break every piece of furniture in their surroundings—the nearest of which is Art itself.

They do not want to submit to any law or to any order; they destroy anything which has a trace of structure, anything which carries a shape of order. They want to be free

of all restraint, be it in reason or in feeling, whether it comes from outside or from within their own consciousness; they want to be free of anything which even remotely reminds them of restraint or form—they want action.

They think that by being shapeless, without order and structure, they will find that complete freedom, so they make paintings and sculptures in which the spectator receives the image of the chaos they experienced in their consciousness.

Now I must say something in their defense. Do not lightly shrug off that phenomenon. Do not try to restrain the convulsive gestures of these artists with a fatherly command to "Sit down and stop it!"

Their action is of baleful significance. They reflect not only a state of their own consciousness but also the state of our society. In their case, it is our society more than themselves that is responsible for their action. It is the threatening chaos hanging over so many aspects of our life that is responsible for what they are doing. It is the state of disintegration of the fiber of an old civilization and the inability of our society to sustain and support those sprouts of a new civilization which are gleaming on the horizon.

Of Divers Arts
VI

The art of this group is received with grave interest by an intellectual stratum of no mean authority, and those members who accept it for serious reasons and not out of fashion and amusement must have something in their consciousness in common with this art.

Those of them, however, who see the true cause of the state of mind in which these artists are do not fail to warn you about its significance. You would do well to listen to their warnings.

I would like also to make it clear that the survey I have made of what is going on in artists' minds today is in no way a criticism of their art. The contrary is the case; I think I understand their experiences, and I am in sympathy with their feelings, although I do not share their views. There are works produced by artists in all the groups that I have mentioned which I consider to be forceful enough to remain as monuments of our epoch in its most critical stage, and they will serve as a good lesson for the coming generation, so that it does not repeat their mistakes.

I said that I do not share their views; indeed, I do not. I share their experiences, but these experiences evoke in my consciousness a different reaction from theirs.

The state of mind in which humanity finds itself today is indeed disturbing. I am distressed, but I do not despair, because I believe that life is indestructible, and the force that makes it indestructible is human constructive consciousness. I believe that human consciousness is a growing force given to us with life, and that its growth is as yet far, far indeed, from reaching its potential limits. It is a force which cannot be broken up into pieces and parts. It does not depend on any one individual's wanton will and whim. It grows and perfects itself with a power all its own.

It is within us, and our life is sustained by it. Human life without its presence is not only meaningless, it is not human. Its presence is revealed to us not by our experiences alone but by the images and conceptions which our consciousness enables us to create as a guide for our action.

Very often, it must be admitted, we make misconceived images, but nothing in our history shows us that our consciousness has ever failed us; it never loosened its control of life when our mistakes became a danger to it.

The greatest mistake we are apt to make is to turn these images into absolutes, and I see that the reason of our ailment today lies in the fact that the images we have made have proved mistaken; let us say, ineffective.

We are faced now with the task not so much of discarding the old images—they are already falling apart by themselves—as of creating new ones to sustain the growth of our culture.

I see the course of human culture as a continuous and unending thread, consisting of innumerable filaments tightly interwoven with each other and having a single direction. Following the course of its history we discern in it a distinct sequence of phases; we observe here and there changes in its volume. Here it gets thinner; there it thickens, and then it begins to turn, winds back on itself and binds itself in a knot; for a while it looks as if it is slowing down; it takes some time to make the knot, but then we see that the thread has never stopped moving; it

Of Divers Arts
VI

flows out of the knot, preserving its main characteristics and following the same direction; we see that, at the phase when it was seemingly slowing and forming the knot, its growth was still uninterrupted.

This is how I see the development of human culture. These phases are vital for the sustenance of the growth of culture. They usually happen when the component filaments of culture begin to disconnect themselves from each other, deteriorate, and threaten to weaken the whole thread—the knots bind them together again and strengthen them.

There is no adequate word to signify these phases in the history of human culture. The words "style" or "tradition" could serve that purpose had they not been so much misused in common parlance that they have almost lost their proper meaning.

"Style," for instance, is so vulgarized as to be a synonym for fashion, a term of taste that can be imposed by an advertising agency one day and changed by another the very next day; whereas styles when we study them in their proper historical array are accumulative results of a formative process of culture when it reaches the highest point in its development and growth.

A style can neither be imposed nor predicted, it grows organically out of the human consciousness in any given epoch, signifying the form and the substance of that epoch.

A tradition also should not be understood as something

static, a permanent set of rules handed down from generation to generation in strict unchangeable patterns which allow no transformation from within; whereas when a tradition reaches that state of permanence, it signifies only one thing, that its growth is exhausted and that it is ready to die.

The words "style" and "tradition" can be used to symbolize these phases I am talking about if and when they are understood as formative stages of growth.

It is my strong belief that we are now experiencing just that kind of turn in our culture. History is making another knot in its course, and a new tradition, a new style, is being formed where many filaments of the old are going to be thrown off; many will remain in culture's later continuation.

Holding this belief, I do not share the common feeling of distress that we have lost our moral and aesthetic sense. We cannot lose these senses, because they are attributes of our consciousness, the mainspring of our drive for life. It is the images, the conceptions, made of them in previous civilizations that are being broken up.

Our forefathers kept beauty and goodness on separate pedestals in a divine garden outside themselves which only some were allowed to enter, if and when their deeds were considered good and beautiful according to the standards of those who created those two goddesses.

They did not know that nothing we make is made

Of Divers Arts
VI

forever. No image which we create of our experience can claim an eternal existence.

The images of goodness and beauty which our forefathers created are not valid for us any more. I believe that beauty and goodness cannot be separated. I do not share the view of those philosophers who assert that "ethics cannot be expressed"; ethics can and has been expressed, but not by philosophic systems nor by the winding arguments of their logic. Ethics has been expressed by prophets and poets through many millennia of our history. The Ten Commandments are not philosophical treatises; neither is the Sermon on the Mount.

Their commanding poems appealed to the core of human consciousness by the force of their concise and compelling imagery, penetrating deep and wide into the hearts of men, making them resonate with the poet's invocation.

Therefore, what we cannot express by the art of thinking, by the art of Science or philosophy or logic, we can and should express by the poetic, visual, or some other arts. It is for that reason that I consider morals and aesthetics as one and the same; for they cover only one impulse, one drive inherent in our consciousness—to bring our life and all our actions into a satisfactory relationship with the events of the world as our consciousness wants it to be, in harmony with our life and according to the laws of consciousness itself.

If we keep in mind that our consciousness is not a privilege of the individual alone but is active in all of us who are living, as a universal force in human life, it will be clear that such a satisfactory relationship cannot be achieved at any individual's pleasure or wanton will. They will always fail as they always did fail in the past history of man. That, I believe, is the cardinal principle upon which we can build anew the images in all our arts, of which Science is but one.

I have, therefore, no need to look back into the memories of our primordial experiences, since I do not experience any fear of the dark forces in Nature which the primitive man saw and experienced. So long as our consciousness is with us, there is nothing destructive in them and nothing to be frightened of. Our consciousness always made them serve constructive purposes and benefited from them. Nor do I look for a hiding place of escape into the images of our nightly dreams, seeking in them for a meaning hidden in our so-called subconsciousness. I do not believe that our consciousness can be divided into separate compartments and cut into separate layers. Consciousness is either with us and we are alive, or it is not, and then we are not in a state of living; to be alive means to be awake and to have the full power which consciousness gives us to create, control, and co-ordinate.

I repeat: We know of no other source of experiences,

Of Divers Arts
VI

be they events outside ourselves or within us, except our consciousness of them. Neither do we have any other frame of reference for evaluating, controlling, or co-ordinating what we do.

Feeling alone or senses and reason by themselves cannot provide such a frame of reference; feeling may lead us astray, senses may deceive, reason may err—but our consciousness as the sum total of all these faculties together is our final frame of reference for all our experiences and all our creations.

Co-ordination is the essential drive of our consciousness, and co-ordination is the form of its structure, the guiding pattern of its operation in us; and as the source of all the creations of man, consciousness does not tolerate amorphous deformities; having the unique faculty of being conscious of itself, it is able to create images of new experiences the origin of which escapes our direct observation.

These are the foundations of my attitude toward the world outside me and the events with which I live, and it is with this notion in mind that I would wish you to reflect upon the reasons of my insistent call for the arts to be constructive.

To be constructive means to me precisely to be guided by the pattern of our consciousness and to create our images according to the structure of our consciousness itself, for only in this way shall we be able to fulfill the task of

keeping the state of mind of the human being, including our own, in balance and in harmony with the laws of life, thus enhancing its growth.

May I conclude with these words of a great poet? Although written nearly a hundred years ago, they have not lost their actuality today.

"It is a happy thing that there is no royal road to poetry. The world should know by this time that one cannot reach Parnassus except by flying thither."[13]

I can add very little to that profound observation. I will say merely this—there is no royal road to any art, as there is no way of least resistance to life itself.

Art is an effort of our consciousness directed toward a specific goal—to know and to make known, to give shape to the shapeless, structure to the discomposed, and to lend form to the amorphous origin of chaos.

NOTES AND INDEX

NOTES

p. 7 1. Theophilus Presbyter, *Schedula diversarum artium*, quoted in C. G. Coulton, *Art and the Reformation* (Oxford, 1928), p. 97.

p. 7 2. Ibid.

p. 8 3. Ibid., p. 98 (slightly paraphrased).

p. 8 4. Ibid., pp. 98–99.

p. 20 5. "Mathematics may be defined as the subject in which we never know what we are talking about, nor whether what we are saying is true."—Bertrand Russell, quoted in Philip E. B. Jourdain, *The Nature of Mathematics*, reprinted in *The World of Mathematics*, edited by James R. Newman (New York, 1956), I, p. 4.

p. 28 6. Gabo, "On Constructive Realism," The Trowbridge Lecture of 1948, reprinted in *Gabo: Constructions, Sculpture, Paintings, Drawings, Engravings*, with introductory essays by Herbert Read and Leslie Martin (London and Cambridge, Mass., 1957), p. 175 (slightly paraphrased here).

p. 86 7. *The Complete Letters of Vincent van Gogh* (3 vols., London, 1959).

p. 100 8. The *Manifesto* was written by Gabo and published over the names of him and his brother, Noton (later Antoine) Pevsner. It is published in both facsimile and translation in *Gabo: Constructions, etc.*, pp. 151–52.

p. 149 9. *M. A. Vrubel: Pis'ma k sestre; Vospominaniia o khudozhnike Anny Aleksandroviy Vrubel; Otryvki iz pisem ottsa khudozhnika* [M. A. Vrubel: Letters to his sister; reminiscences of the artist by A. A. Vrubel; excerpts from letters of the artist's father], with an introduction by A. T. Ivanova (Leningrad, 1929), p. 18.

p. 151 10. Ibid., p. 96 (letters of 1885).

p. 153 11. C. P. Yaremich, *Mikhail Aleksandrovich Vrubel; zhizn i tvorchestvo* [Life and creation], with an introduction by Igor Grabar (Moscow, 1911).

p. 179 12. Benjamin Franklin, quoted in *A Treasury of Science*, edited by Harlow Shapley, Samuel Rapport and Helen Wright (4th rev. edn., New York, 1958), p. 269.

p. 194 13. Extract from an early diary (1864) of Gerard Manley Hopkins, quoted in his *Poems and Prose*, edited by W. H. Gardner (Harmondsworth, 1953), p. 93.

INDEX

Page references in italics indicate illustrations.

images, 28, 65; to artist and to scientist, 69; communication of
 visual, 63; creation of new, 188; multiple, and nature, 56;
 of primitive man, 183; scientific, of world, value, 58; visual,
 of experience, 119
Impressionists, 40–42
inspirations, 10f

Joseph with shepherd (Novgorod), *144*
"Jupiter of the Decadents," 152, 154

Kiev, 151f; Vladimir Cathedral, *165*
kinetic paintings, *95*, *97*, *105*
knowledge, 13; art and, 24
Kovalevsky, *143*

Ladle (Russia), *126*
landscape, 120
Landscape with Cypress Trees (van Gogh), *82*
Landseer, Sir Edwin, *35*
Lermontov, M. G., *160–163*, *169*
Levitsky, Doctor, portrait (Vrubel), *171*
light: and color, 98; and space, 98; structure of, 88
line: artist's conception of, 67f, 84; definition of, 66; *see also*
 elements
linear constructions (Gabo), *frontispiece*, *107*, *117*
lion with horse's head (Russia), *125*
Little Gardens on the Butte Montmartre (van Gogh), *81*
Logan Rock (Gabo), *109*

Madonna and Child (Vrubel), *158*
Magdalenian paintings, *71*, *72*, *73*
Malatesta, Sigismondo (Piero della Francesca), *80*
Malevitch, Kasimir, *173*
Man, "the Stranger," 12f, 15
Martyr, A (Kovalevsky), *143*
mathematics, 20, 53, 66f, 101
Matisse, Henri, *83*
meaning, in art, 120
means, visual, 64ff
measurement, 54, 67: of time, 101
Melchizedek (Theophanes), *138*, *139*
memory, visual, 65
Merrie Wives of Windsor, design for (Vrubel), *164*
Merytyetes, Princess, *78*
Michelangelo, 150
Mir Iskusstva, 153
Monet, Claude, *41*
Montmartre, Butte (van Gogh), *81*
Mont Sainte-Victoire (Cézanne), *168*
morals, and aesthetics, identity of, 191
Moscow, 152; Annunciation Cathedral, *140*; Rogozhinski Cemetery,
 133; Troyski Cathedral, *136*
Mother of God (Rublev School), *134*
movement, in line, 67

This book was set in Monotype Walbaum and printed by Clarke & Way, Inc., New York, on Warren's Cumberland Dull coated paper. It was bound by Russell-Rutter Company, Inc., New York. Both the monochrome and the four-color plates were made by Publicity Engravers, Inc., of Baltimore. Andor Braun designed the format.